The Campus History Series

MILTON HERSHEY

SCHOOL

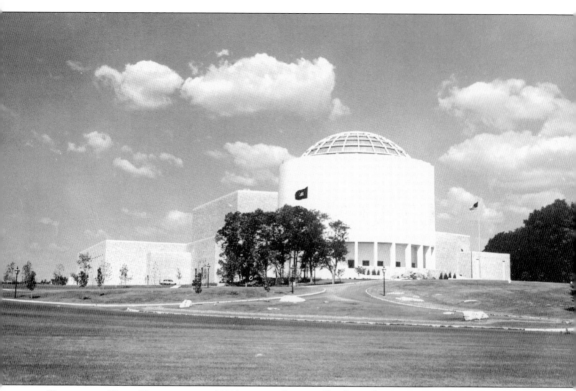

FOUNDERS HALL DEDICATION, 1970. Founders Hall, the administrative center of Milton Hershey School and a physical memorial to the school's founders, was dedicated on September 13, 1970. Completion of the building and its soaring rotunda marked the end of a decade-long expansion of facilities and programs.

On the cover: **VISITING WITH THE BOYS.** Milton S. Hershey (1857–1945) was a frequent visitor to the boys enrolled at his School. Here he takes a moment to sit on the front steps of the Homestead—the place of his birth and first home to the school—with a group of "his boys" on a sunny summer day in 1913. (Courtesy of Milton Hershey School Department of School History.)

The Campus History Series

MILTON HERSHEY SCHOOL

James D. McMahon Jr.

ARCADIA
PUBLISHING

Published by Arcadia Publishing
Charleston SC, Chicago IL, Portsmouth NH, San Francisco CA

Printed in the United States of America

Library of Congress Catalog Card Number: 2007942393

For all general information contact Arcadia Publishing at:
Telephone 843-853-2070
Fax 843-853-0044
E-mail sales@arcadiapublishing.com
For customer service and orders:
Toll-Free 1-888-313-2665

Visit us on the Internet at www.arcadiapublishing.com

*To all the students, staff, alumni, and retirees of Hershey
Industrial School and Milton Hershey School—the living
legacy of Milton and Catherine Hershey. And most of all to
Mr. and Mrs. Hershey for their vision and generosity.*

CONTENTS

ACKNOWLEDGMENTS

This book would not have been possible without the efforts and hard work of Susan Alger and Sally Purcell, department of school history, who worked tirelessly to unearth and rescan the images selected for this book. Additional thanks go to Erica Myers, office of communications, for supplying a number of contemporary images.

I also want to thank those individuals who helped review text, check facts, and otherwise contributed their experience and expertise to the review of this book. They include William Fisher '50, Peter Gurt '85, Connie McNamara Jeffrey, J. Bruce McKinney '55, and Lewis Webster, members of the Centennial Celebration Steering Committee; Dr. Joseph A. Brechbill, curator emeritus, department of school history; John McClellan "Mac" Aichele '39 and Kenneth Hatt '41, longtime members of the Milton Hershey School community; and senior administrators James Sheehan and Joan Singleton.

This book would not exist without the enthusiastic support of Johnny O'Brien '61, president of Milton Hershey School and the Milton Hershey School Board of Managers. I am especially grateful for the time each member of the board of managers took from his or her busy schedules to review this manuscript and to communicate their thoughts and impressions.

FOREWORD

The United States of America is blessed with a deep history of extraordinary philanthropists. And Milton Hershey may well stand first among them. Not because he gave the most money, because some gave more. Rather what distinguishes Mr. Hershey is why he gave—a motivation made unmistakably clear by the way he gave.

Milton and Catherine Hershey's $60 million gift to what would become the Milton Hershey School was first revealed in a front-page story in the *New York Times* on November 9, 1923. It was a gift of staggering generosity, worth more than $700 million in today's dollars. But the most impactful aspect of that extraordinary gift, for me at least, was quietly revealed later in the article. It was the fact that Mr. Hershey had actually made the donation five years prior, but did not disclose it publicly.

Think about that. Most philanthropic gifts are heralded in elaborate press conferences, with speaker after speaker ascending to the microphone to give thanks and praise to the benefactor. But what a contrast Mr. Hershey carved! Imagine giving such a historic gift—virtually your entire hard-earned fortune—and then never telling anyone. There was no PR plan to win credit, fame, or praise. Nor was there any financial advantage; in those days, there was not even an income-tax deduction to be gained. No, the Hersheys' gift came from one motive only: love for children afflicted by misfortune. The Hersheys did not have biological children. But theirs is one of the most inspiring stories of parental love I ever have known.

And that is why everyone of us who works today with his school feels an overriding sense of awe and privilege, awe at the Hersheys' generosity. And privilege to play a role in keeping it alive—and extending it to others. And that generosity was matched by wisdom. Mr. Hershey strategically crafted his deed of trust so that the school would serve children in perpetuity. And so it will. In its first 100 years, more than 18,000 children have been directly served by the school. And in the next 100, through hard work and allegiance to his trust, we will serve many more.

But the men and women who will do that hard work will be the first to say that the credit belongs, not to them, but rather to a remarkable man and woman—and their extraordinary gift of true, pure love.

—LeRoy S. Zimmerman
Chairman Board of Managers

INTRODUCTION

*I have no heirs, that is, no children, so I decided to make the orphan boys
of the United States my heirs.*
—Milton S. Hershey, January 1934

Reading through these pages, poring over the photographs, I feel as if I am looking through a family album, reminiscing about brothers and sisters and recalling homespun memories.

From the time I came to what was then called the Hershey Industrial School, just before my fourth birthday, this was the home that saved and shaped me. It was here that I learned about commitment and hard work, and here that I learned the importance of serving others. Mr. Hershey's visionary act of generosity saved my life. But his impact, and the impact of the school he started, extends far beyond its effect on any student.

In a very real sense, when Mr. Hershey created the Milton Hershey School, he unleashed a reaction similar to a pebble tossed into a lake. The concentric waves produced by Milton Hershey School will continue in perpetuity. Each and every individual whose life was transformed by their time in the school has gone on to touch other lives, and so the circle continues to grow. Mr. Hershey once said that if his school could help 100 boys, it would have been worth it. So far, more than 18,000 boys and girls have passed through this institution, transforming their futures and offering them the chance of success.

I am honored to serve my home as it celebrates its first century. This administration has worked diligently to fulfill Mr. Hershey's legacy, growing and expanding our home and school while always remaining true to our deed of trust.

But Mr. Hershey did not envision this school to stand for 100 years. He envisioned it to last forever. And so, the real significance of the story told on these pages is that it continues to unfold. What's remarkable is not just the history already made; it is the history still to be made. It is not just those lives changed, but those lives still to be changed.

And so, our noble mission continues, and the legacy of a man who gave all that he had to make a difference goes on changing the future, one student at a time.

—Johnny O'Brien '61
President, Milton Hershey School

One

I WAS A POOR BOY MYSELF ONCE
1857–1908

Milton Snavely Hershey was born September 13, 1857, in a stone farmhouse on what is now the campus of Milton Hershey School in the town of Derry Church (now Hershey), Pennsylvania. He was the only surviving child of Henry and Veronica "Fanny" Hershey. Both parents shared a Pennsylvania German Mennonite heritage. Fanny, a plain-dressing woman, adhered to the Reformed Mennonite Church values of thrift, hard work, and frugality. Although Milton never became a member of the Reformed Mennonites, he was strongly influenced by their values. Henry, noted for his alert and inquiring mind, lacked the necessary perseverance to succeed in the multitude of projects and dreams he envisioned. Milton was able to combine the best qualities of both his parents: from his father, a love of invention and adventure, and from his mother, a sense of industry and perseverance. Though differences in personality and temperament between husband and wife led to their eventual estrangement, Milton remained close to each of them throughout his life.

Because the family was constantly on the move, Milton received little formal education or continuity in his studies. His father was often away for long periods, and his mother made little effort to correct the impression that she might be widowed. This situation may have contributed to Milton's later interest in creating a school devoted to the education and welfare of orphaned boys. In an effort to teach his son a trade in line with his own interests, Henry eventually apprenticed his son to a local printer. Milton was ill-suited to the work, and the experiment did not last long. His mother than took control of his education and apprenticed him for a period of four years to Joseph Royer, a successful confectioner in the neighboring city of Lancaster. For the next several years, his mother and her sister Martha "Mattie" Snavely would be his chief supporters.

In 1876, 18-year-old Milton established his first candy-making business in Philadelphia. He hoped to find a ready market for his candy in the Centennial Exposition crowds. After six years of hard work, and even with the support of his mother and aunt, his business

9

failed. That same year, he left Philadelphia to follow his father to Denver, Colorado, to try his luck in mining silver. When this venture failed, he took a job with a Denver candy maker. Here he learned the secret of making caramels with fresh milk, which improved their flavor and kept them fresh. In 1883, Milton traveled to New York City to try again in the candy making business. Despite a good product and tireless effort, he failed again. In 1886, after three years in New York City, he returned to Lancaster where he founded the Lancaster Caramel Company. Here he put to good use the secrets he learned in Denver and within a short time was able to turn a profit.

The rapid development of the chocolate-making industry did not escape the keen confectioner's eye of Milton. In 1893, he visited the Columbian Exposition in Chicago where he viewed and purchased chocolate-making equipment, founding the Hershey Chocolate Company in 1894. The immediate success of his chocolate company convinced Hershey that he would need a much larger factory. He sold his Lancaster Caramel Company in August 1900 for $1 million, which he then used to expand his chocolate business. After considering several urban sites along the eastern seaboard, he chose a site near the place of his birth to start his new venture. Here at the Homestead Farm, he continued to perfect his formula for making milk chocolate, while at the same time finalizing his plans for construction of what would become the largest chocolate factory in the world.

The financial successes of the Lancaster Caramel Company and the Hershey Chocolate Company allowed Milton opportunities to explore the finer things in life, to travel, and to meet new people. To the surprise of his family and friends, and most of all to his mother, Milton married Catherine "Kitty" Sweeney on May 25, 1898. On the surface, the two appeared to have little in common—she a Roman Catholic and he the product of a Mennonite family—but by all accounts, their marriage was a happy one. She brought joy and beauty to his life, companionship, and a shared sense of purpose. She also created in him an awareness of the importance of giving back, a sentiment which would also influence their joint decision to create the Hershey Industrial School for orphaned boys in 1909.

FANNY HERSHEY, 1918. Veronica "Fanny" Hershey (1835–1920), also known as Mother Hershey, wore the plain garb of the Reformed Mennonite Church throughout much of her life. She did not share her husband's enthusiasm for new ideas and adventure and instead worked tirelessly for her son on behalf of his early business ventures. She remained a cherished advisor to her son throughout his life.

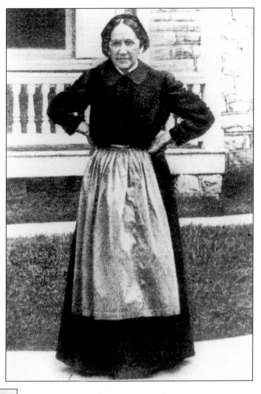

HENRY HERSHEY, C. 1900. Henry Hershey (1829–1904) was a man of imagination and action who loved books and was never at a loss for words. He was always willing to try something new but was never successful at making a living. By his son's own count, he had tried and failed in at least 17 separate business schemes during his life.

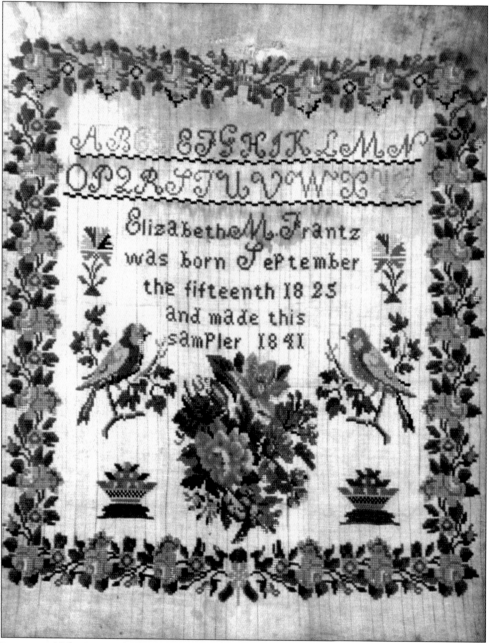

SAMPLER, 1841. Typical of the samplers stitched by young women of the period to show their skill in domestic sewing, this example was sewn by 16-year-old Elizabeth M. Frantz. Elizabeth was the wife of Henry Hershey's youngest brother Elias. Like Henry, Elias was a great reader, self-educated and well informed; however, unlike his brother, Elias closely followed the doctrines of the Reformed Mennonite Church and eventually became a bishop. Milton Hershey always looked up to his Uncle Elias (who taught Milton for a year at the one-room Derry Church School in Derry Church) and in his later years, often said that his uncle was his manly ideal. The sampler now hangs in the first floor of the Homestead.

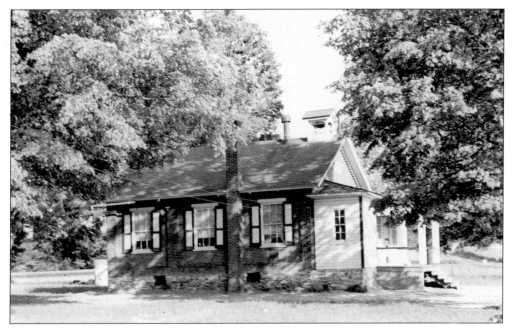

HARMONY SCHOOL, 1954. After leaving Derry Church, the Hershey family lived for several years in the small village of Nine Points in neighboring Lancaster County where Milton attended a number of one-room schools, including the Harmony School. As a boy living on a farm, Milton learned to appreciate the advantages a pastoral upbringing could provide and to value the qualities of thrift and hard work.

MILTON HERSHEY, *c.* 1872. As an apprentice confectioner, Milton learned that candy making was as much an art as a science and that he needed to rely on his innate abilities and talents in developing tasty confections. Though his family life was unsettled, Milton always valued the experiences of life on the farm in Nine Points and the lessons learned in the candy shop of Joseph Royer.

13

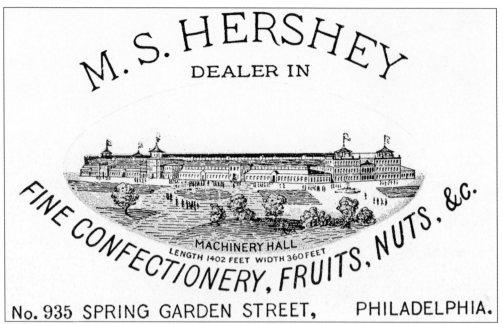

M. S. HERSHEY

DEALER IN

MACHINERY HALL
LENGTH 1402 FEET WIDTH 360 FEET

FINE CONFECTIONERY, FRUITS, NUTS, &C.

No. 935 SPRING GARDEN STREET, PHILADELPHIA.

TRADE CARD, 1876–1879. Approximately one-quarter of the nation traveled to Philadelphia in the summer of 1876 to visit the exposition held in honor of the nation's 100th birthday. With an eye toward capturing the centennial market, Milton Hershey's first business card pictured the Centennial Exhibition's Machinery Hall. By 1882, he was out of business, hampered by small volume, an overly diverse product line, and little cash flow.

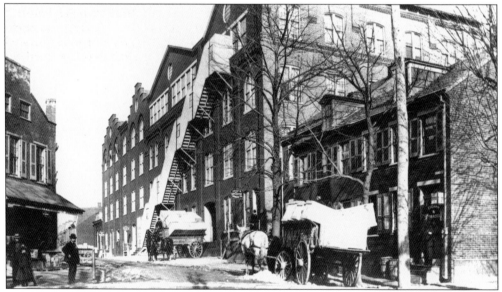

LANCASTER CARAMEL COMPANY, c. 1895. Despite his many business setbacks, Milton never gave up, eventually achieving success manufacturing caramels. His experiences as a child and young confectioner had taught him the value of hard work and perseverance. The Milton Hershey School code of conduct known as the Milton Hershey Way includes four sacred values (integrity, positive spirit, commitment, and respect) based on Milton's own life experiences.

HOMESTEAD FARM, 1898. This is the earliest known photograph of what Milton called the Homestead Farm where both he and his father Henry were born. Isaac and Anna Hershey (great grandparents of Milton) built the central stone section of the Homestead in 1826 for their son, Jacob. In 1867, Jacob sold the home to Henry Gingrich, a fellow Mennonite farmer, who added frame additions to each end. Milton purchased the property at auction in September 1896 and took ownership of it on April 1, 1897. Hershey made numerous improvements to the property and used it for a variety of purposes before it became home to the newly-created Hershey Industrial School in 1909. Over the years, even as the school has grown and expanded, the Homestead has remained the physical and emotional "cradle of the school," a physical reminder of the values of the Hersheys and the history and traditions of Milton Hershey School.

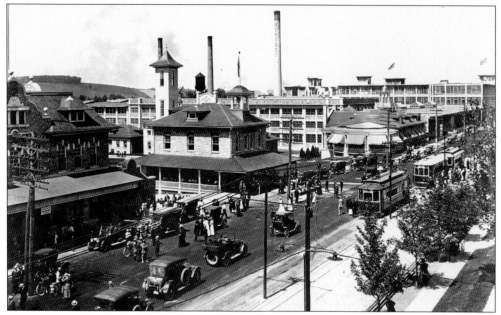

DOWNTOWN HERSHEY, 1915. Milton Hershey broke ground on construction of his new chocolate factory on March 2, 1903. From the start, he envisioned a planned model community. His interest in the welfare of his workers was neither unique nor unprecedented; however, the town of Hershey, and later the Milton Hershey School, came to reflect the unique beliefs and personality of their creator who took a personal interest in both.

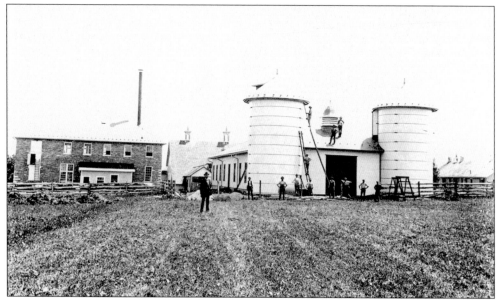

HOMESTEAD FARM AND EXPERIMENTAL PLANT, 1901. Milton brought his father Henry home to live at the Homestead in 1898, where he lived until his death in 1904. Henry (in the foreground) took a great interest in the changes his son made to the Homestead Farm property. The new Experimental Plant where the formula for Hershey's milk chocolate would be perfected is on the left. The Homestead is on the right.

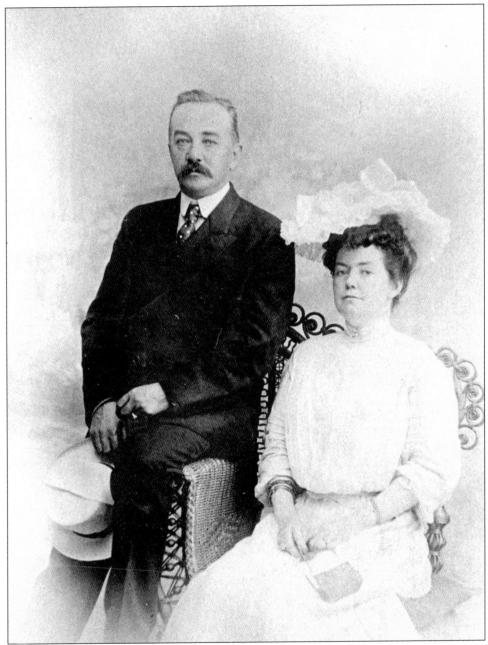

STUDIO PORTRAIT, NICE, FRANCE, 1905. Milton and Catherine Hershey were married in the Rectory of St. Patrick's Cathedral in New York City on May 25, 1898. Catherine (1871–1915) was born in Jamestown, New York. It is believed that the two met during one of Milton's frequent business trips, although the details of their courtship are not known. This particular photograph, though not of their wedding, is the earliest known portrait of the two of them together. At the time of their marriage, he was 40 and she was 27. Her early death in 1915 left him devastated, and he never remarried. Instead he devoted the next 30 years of his life to expanding the chocolate company, improving the town, and nurturing the school they both worked so hard to establish.

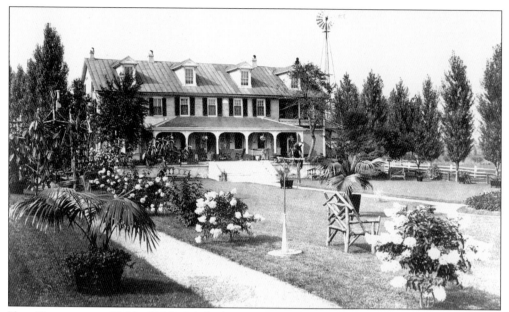

THE HOMESTEAD, 1905–1908. With the passing of Henry Hershey in February 1904 and construction of the factory nearly complete, Milton and Catherine Hershey made the decision to live at the Homestead while High Point (their new home) was being constructed. Before moving into the Homestead, they carried out a number of renovations, including the addition of a new porch and roof-top dormers, to modernize the structure, which had already served several generations as the heart of a thriving agricultural as well as industrial village. The grounds were also landscaped and groomed to reflect the genteel tastes of the Hersheys. When the Hersheys moved into High Point in 1908, the Homestead became available to serve a new—some might say higher—purpose as home to a school for orphaned boys.

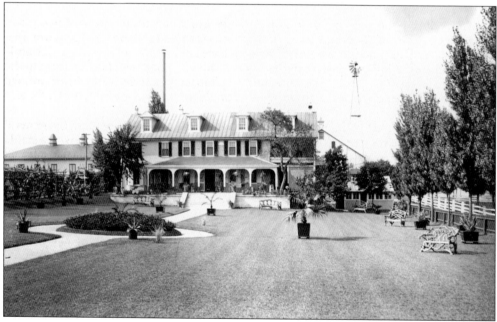

Two

IT WAS KITTY'S IDEA
1909–1928

On November 15, 1909, Milton and Catherine Hershey signed the deed of trust establishing what was then known as the Hershey Industrial School. The deed transferred 486 acres of good farmland in the vicinity of the Homestead Farm to the Hershey Trust Company, "with the purpose of founding and endowing in perpetuity" their school for orphan boys. Healthy orphan boys (boys whose fathers had passed away) between the ages of four and eight were to be admitted at the discretion of the Milton Hershey School Board of Managers, of which Milton was chairman. The requirements for admission would, of course, expand over the years in response to the demands of society and the resources of the school.

Though it is difficult to point to any one reason for the couple to have made this momentous decision, it became increasingly obvious to both Milton and Catherine that after 11 years of marriage they were not going to have any children of their own. Certainly the deficiencies of Milton's own experiences as a child coupled with his exposure to the Mennonite value of benevolence undoubtedly influenced their decision. When pressed by others for an explanation, Milton would simply and matter-of-factly state, "It was Kitty's idea."

Although the precise course of study was not dictated in the deed of trust, the general educational objectives were clearly explained; each boy was to be provided with a stable home life, a sound education, and vocational training. Remembering the happy hours he himself had spent on the farm, Milton felt it important that this education included learning about agriculture, horticulture, and gardening, as well as caring for animals. He was sure that such experiences would benefit the boys by teaching them to care for something other than themselves. Remembering the age of the boys, early teachers and administrators had their students grow fruits and vegetables in truck patches adjacent to the Homestead. To help provide the boys with a sense of satisfaction, much of what was grown was used on their own tables.

George Copenhaver, a former schoolteacher who had recently been appointed supervisor of the Hershey Farms, became superintendent of the school. His wife, Prudence, who had also been a schoolteacher, joined him in caring for the children and in developing the home life program for the boys. After taking time to ready the Homestead, the

19

Copenhavers welcomed the first four boys in September 1910. Within a few short weeks their number had grown to 10. As might be expected, the boys were often homesick after they arrived, but soon they warmed to the whole new world open to them. Many of the boys liked to fish or swim in summer or skate or sled in winter. Since the boys lived at the Homestead with the Copenhavers rather than at High Point Mansion with the Hersheys, Milton made it a priority to visit the boys as often as he could. Catherine, however, was not comfortable visiting the boys at the Homestead. She suffered from a type of progressive illness, described as a "creeping paralysis," which had begun to manifest itself early in her marriage. Instead Milton brought the boys (a class at a time) to High Point Mansion once a year for breakfast—a tradition which he continued after Catherine's unfortunate death on March 25, 1915.

The success of the school meant that the Homestead quickly outgrew the needs of the boys. Many of the buildings in and around the Homestead, which at one time had served the needs of the old experimental chocolate plant, were quickly converted into classrooms, dormitory, or mechanical space. Throughout the 1920s, several new buildings constructed specifically to meet the educational and residential needs of the boys were erected in the area around the Homestead, culminating with the opening of a state-of-the-art elementary school in 1927.

In less than 20 years, the Hershey Industrial School had grown from an enrollment of 4 students in 1910 to over 200 students by 1927. Despite the great strides being made in accommodating the basic needs of students, it was apparent to those in charge that the home program was bursting at the seams, and the academic and vocational curriculum of the school needed to be strengthened. The boys who had come to the school as children were now young men, who presented entirely new and different challenges to those who cared for them. The Hershey Industrial School was ready for change.

Deed of Trust, 1909. The 23-page typewritten document to which the Hersheys affixed their signatures provided in part that, "All orphans admitted to the School shall be fed with plain, wholesome food; plainly, neatly, and comfortably clothed, without distinctive dress, and fittingly lodged. Due regard shall be paid to their health; their physical training shall be attended to, and they shall have suitable and proper exercise and recreation. They shall be instructed in the several branches of a sound education, agriculture, horticulture, (and) gardening . . . bearing in mind that the main object in view is to train young men to useful trades and occupations, so that they can earn their own livelihood."

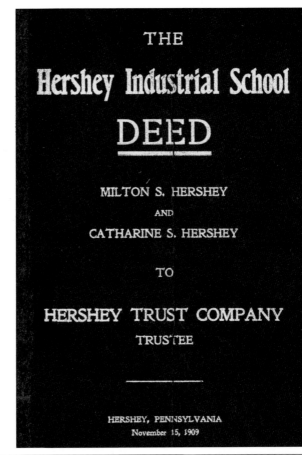

THE

Hershey Industrial School

DEED

MILTON S. HERSHEY

AND

CATHARINE S. HERSHEY

TO

HERSHEY TRUST COMPANY

TRUSTEE

HERSHEY, PENNSYLVANIA
November 15, 1909

IN WITNESS WHEREOF the parties of the first part hereto have hereunto set their hands and affixed their seals this fifteenth day of November, in the year of our Lord one thousand nine hundred and nine.

Signed, sealed and delivered in the presence of :

_____ (SEAL)

_____ (SEAL)

21

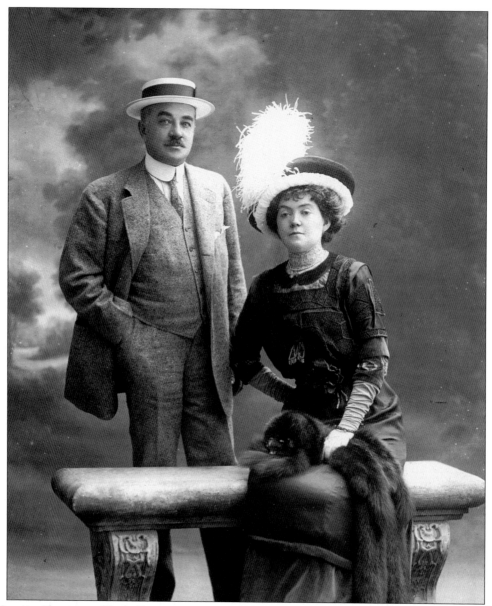

Studio Portrait, Nice, France, 1910. Milton and Catherine Hershey loved to travel, especially to the Mediterranean. As Catherine's illness progressed, these trips were increasingly made to visit spas and consult with specialists who thought they could help Catherine with her illness. During the winter months, the warm climate of the Riviera also helped Catherine to take her mind off her deteriorating physical condition. This portrait shows the couple as they appeared at about the time they signed the deed of trust. They probably chose to sign the deed in New York City because of its convenience—they left for Europe on a ship from New York City just a few days later—and its symbolism. New York City held fond memories for the couple. Here they had been married in the rectory of St. Patrick's Cathedral. New York City was the place where they started their life together and would be the place where they signed the document that would ultimately create the family they so longed for.

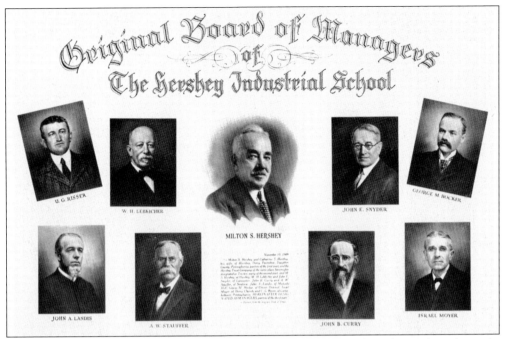

BOARD OF MANAGERS, 1909. Milton seemed to always have the knack to select the right person for the right job. The original Milton Hershey School Board of Managers included several local businessmen as well as the lawyer who had drawn up the deed of trust (John Snyder), a local physician to supervise medical care (U. G. Risser), and a local minister (John A. Landis) to oversee moral and religious instruction.

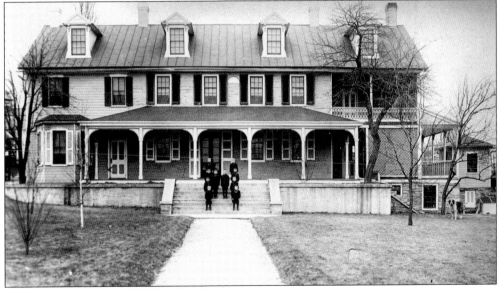

FIRST BOYS, 1910. George Copenhaver was an avid photographer who maintained a darkroom in the basement of the Homestead. He most likely selected this pose to amuse the boys, but it is unclear whether he meant the "H" to stand for Hershey or for Homestead. The boys named the stray dog pictured on the right "Monday" in honor of the day they found him.

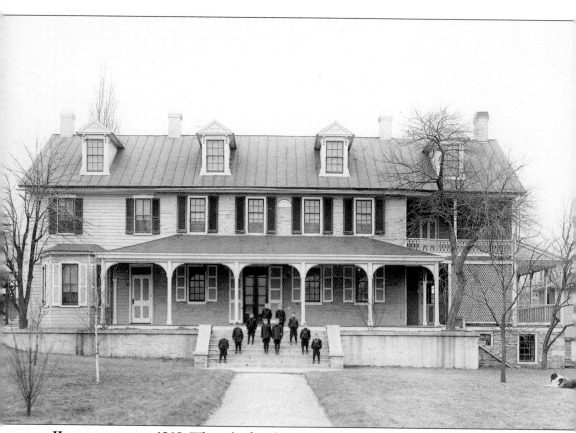

HOMESTEAD STEPS, 1910. When the first boys arrived at the school in the fall of 1910, the Homestead was the school, serving as both home and school for the boys, residence for the first superintendent and his wife, and administrative center. As enrollment increased the adjacent buildings of the old experimental chocolate plant were converted to shops, classrooms, and dormitory space. Eventually new buildings were added to the area in and around the Homestead, which came to be known as "The Main" to generations of staff and students. Over the years, even as the school has continued to grow and expand, the Homestead has remained the cherished centerpiece of the school.

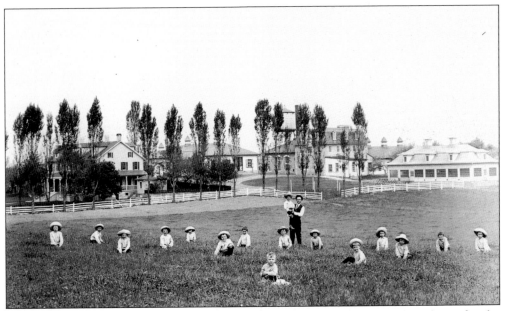

HOMESTEAD CAMPUS, 1912. George Copenhaver was well suited to teach and care for the boys of the school. A graduate of the Lutheran Seminary at Berrysburg in Pennsylvania, he chose to enter the teaching profession rather than the ministry and had spent some time managing farms before coming to the Hershey Industrial School. He would remain as superintendent until his death on February 11, 1938.

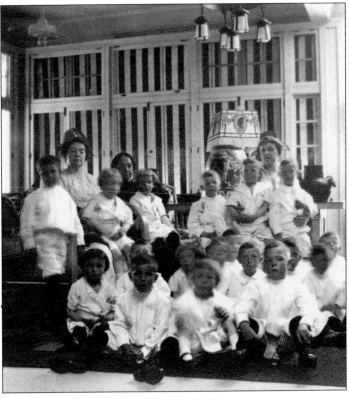

A VISIT TO HIGH POINT, 1912. Prudence Daniel Copenhaver, like her husband, was a teacher and graduate of the Berrysburg Seminary. Prudence, pictured here with Fanny (center) and Catherine Hershey (left), worked closely with Catherine to establish the original home program of the school. She held the esteemed title of matron and continued to follow what she believed to be Catherine's wishes until her own death on August 4, 1949.

BREAKFAST AT HIGH POINT. Milton and Catherine Hershey made every effort to stay in touch with the boys—their boys—at the school. As Catherine's disease progressed, she became increasingly uncomfortable and unsure of herself in public. Breakfast at High Point provided an opportunity for Catherine to see for herself that the boys were being properly attended to and cared for in accordance with her wishes and desires.

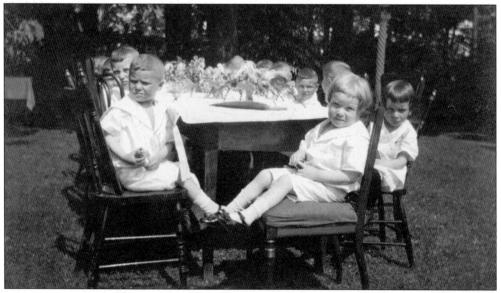

BREAKFAST AT HIGH POINT c. 1912. The boys were always on their best behavior when invited to visit the Hersheys at High Point. Here on the back lawn, a less formal table is set, replete with treats and sweets, where even the dress of the boys is more relaxed. It was not uncommon for boys who visited High Point to receive a present or other small reminder of their visit.

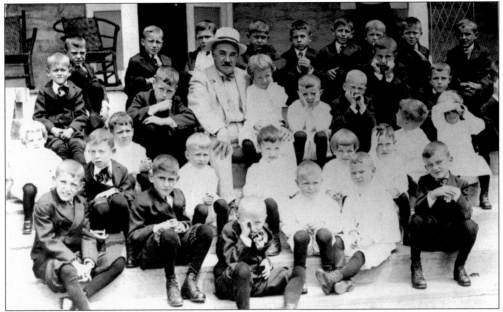

HOMESTEAD STEPS. Milton was a frequent visitor to the Homestead. The boys cherished memories of these visits and proudly shared them with others. In a survey of alumni made in 1962, David Schaffner '23 remembered, "Mr. Hershey now and then would pick one of us up, sit him on his lap and rock away in his rocking chair."

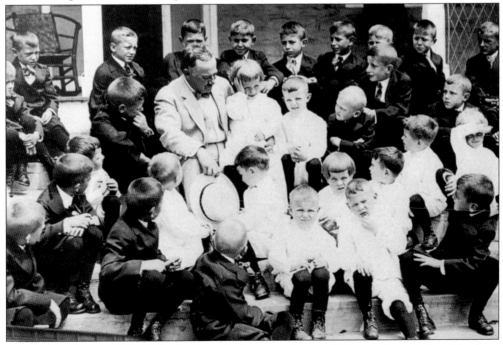

HOMESTEAD STEPS, 1913. With the formal photograph over, Milton acknowledged the heat of a hot summer day by removing his hat and enjoying a few moments of quality time with a group of his boys. Brothers Nelson and Irvin Wagner and Jacob and Guy Weber were the first four students to enroll in the school in September 1910.

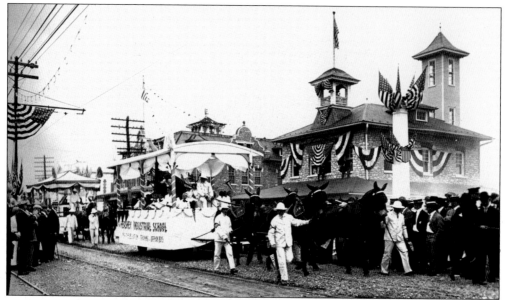

HERSHEY 10TH ANNIVERSARY PARADE, 1913. The town of Hershey threw a gala commemorative celebration, 10 years after breaking ground for the construction of the chocolate factory. Activities included speeches, presentations, and even an aerial barnstormer. A parade down Chocolate Avenue, the main thoroughfare of the town, served as a highlight of the celebration.

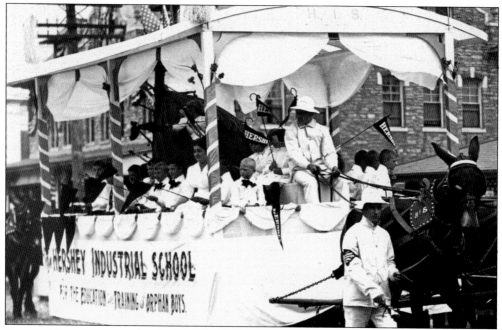

SCHOOL FLOAT, 1913. The boys of the Hershey Industrial School were proud of their school and of their adopted community. To show their support for the town, they entered their own float into the parade, carrying pennants emblazoned with the word "Hershey" and proudly promoting their school as being, "For the Education and Training of Orphan Boys."

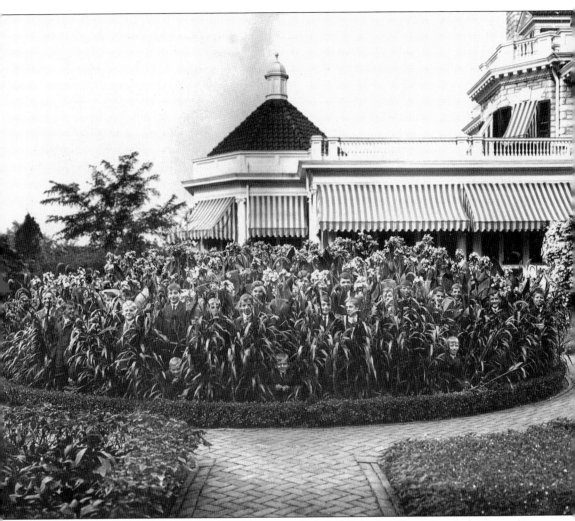

HIGH POINT, 1915. Perhaps because of his unsettled childhood, Milton Hershey seemed to always take a special interest in celebrating that which is common to all and unique to each—birthdays. On the occasion of his mother's 80th birthday, Milton prepared a surprise party for her at High Point. The event was big news in *Hershey Press*, the local newspaper, which noted, "It was one of the jolliest breakfasts ever served. Mrs. Hershey was of course the chief guest and presiding at the table was her son, while all around were the happy youngsters from the Hershey Industrial School, their appetites keen, their voices musical with merriment. Afterwards Mr. Hershey told them to hide themselves in the big canna bed and let the photographer take their pictures. The result was a remarkable photograph in which flowers, urchins, and sunshine are delightfully combined."

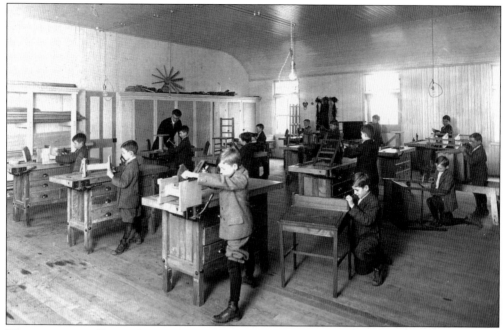

WOODWORKING CLASS, HOMESTEAD BARN, 1912. In 1912, George Copenhaver hired 18-year-old Harold Cool, a graduate of Pennsylvania's Bloomsburg State Teachers College, as the school's first teacher. In the converted dairy barn that served as his classroom, Cool exposed his students to both the academic and practical aspects of education. Woodworking proved to be a popular vocation with many of his students.

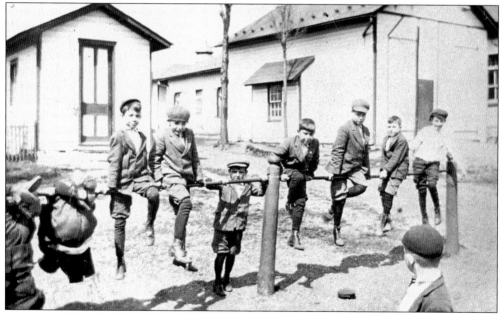

BOYS AT RECESS, 1912. Though the boys were kept busy in the classroom and at home, there was always time to relax and just be boys. Like Copenhaver, Cool was an avid photographer. Though he only spent one year at the school, the photographs he took of his students are an enduring reminder of the early days of the school.

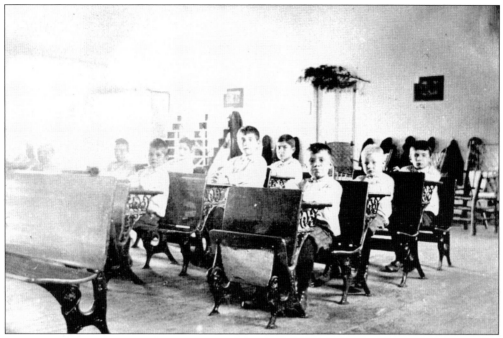

ACADEMIC CLASSROOM, HOMESTEAD BARN, 1912. Cool served as both academic and vocational instructor, even teaching the boys how to plant seeds and harvest plants. According to the *Hershey Press*, the desks, chairs, and bookcases produced in woodworking class were, "made on the grounds with the boys' help as they then have a personal interest in them and take more care that they are not broken."

HAROLD COOL WITH STUDENTS, 1912. Fresh out of school and full of energy and creativity, Cool proved to be popular with his students. He would often take the students on long hikes and provide them with lunches packed by the school cook. On his daily trip to the Homestead, Cool would often run the trolley car if the motorman was in a good mood.

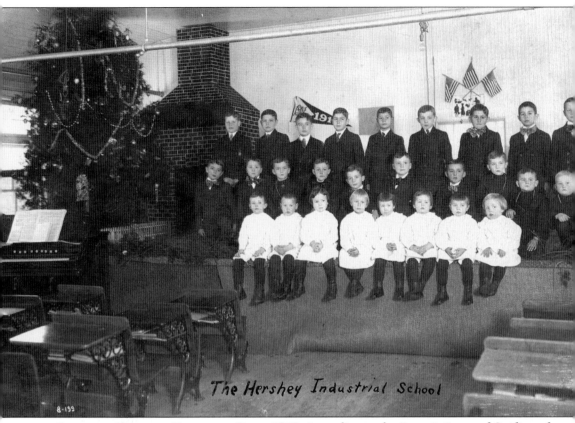

The Hershey Industrial School

CHRISTMAS PROGRAM, HOMESTEAD BARN, 1912. According to the *Description and Outline of Courses of Study*, 1926, "The School is nonsectarian but the moral and religious training of the boys is carefully looked after. No favoritism is shown to any particular sect or creed. Each boy is taught to speak the truth at all times and to respect every religious principle. The first act of the boy on rising is to kneel at his bedside and offer a morning prayer. This is followed by morning worship in the assembly room. A general unison prayer is offered before each meal. On retiring the boy again kneels at his bedside and offers an evening prayer. On Wednesday night we have Bible Study. On Sunday morning at 9:00 o'clock we have Sunday School. The boys go to any church in the community that they prefer and religious programs are given on Christmas, Easter, Thanksgiving, etc."

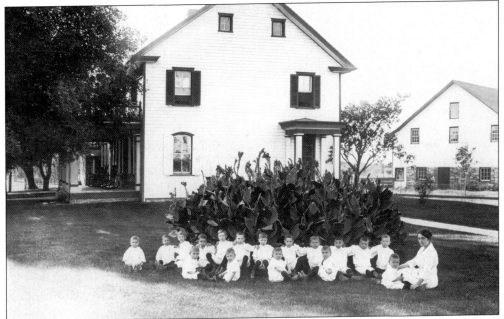

KINDERHAUS, 1912. As enrollment increased, Milton Hershey decided to move the youngest boys out of the Homestead and into a nearby farmhouse, which he called "Kinderhaus," meaning children's home. Here Carrie Simmons served as governess, Violet Stauffer as teacher, Mrs. Herbert Straub as cook, and Virginia Yetter as seamstress. Yetter made all the suits for the smaller boys, including the special white suits worn on Sundays.

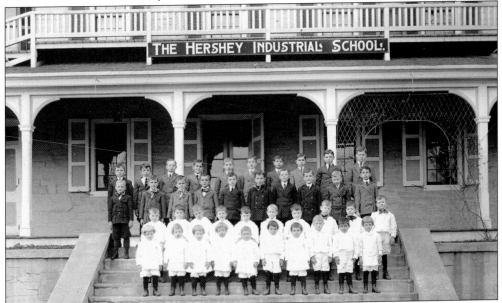

HERSHEY INDUSTRIAL SCHOOL, 1914. According to the *Description and Outline of Courses of Study*, 1926, "The School does and always will give the boys a good course in reading, writing, arithmetic, geography, history, English composition, chemistry, elementary botany, physics, civics, spelling, etc. . . . our course of industrial training is so arranged that actual practice will keep pace with the technical instruction in every line of study."

33

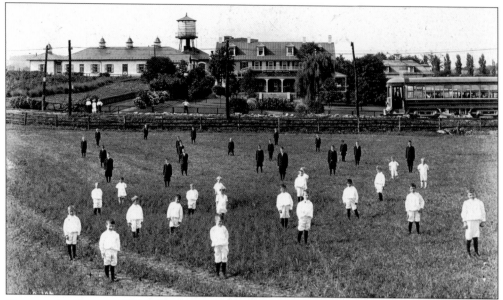

HOMESTEAD CAMPUS, 1914. By 1914, enrollment at the school had reached 40 boys. The converted dairy barn used as classroom space for the boys is located to the left of the Homestead. A trolley of the Hershey Transit Company, perhaps operated by Harold Cool on this very run, is visible on the right. Visitors, residents, workers, and students of the school all used the trolley system built by Milton Hershey.

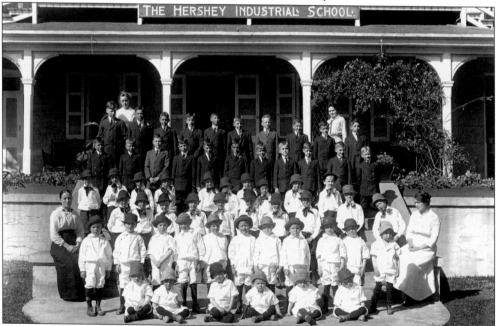

HERSHEY INDUSTRIAL SCHOOL, 1915. According to the *Description and Outline of Courses of Study*, 1926, "We learn to do by doing, and we expect the boys as part of their education, to do the work of plowing, planting, cultivating, harvesting and caring for the domestic animals. The boys also raise small fruits and vegetables. We propose to have the boys use their hands with their brains and develop both."

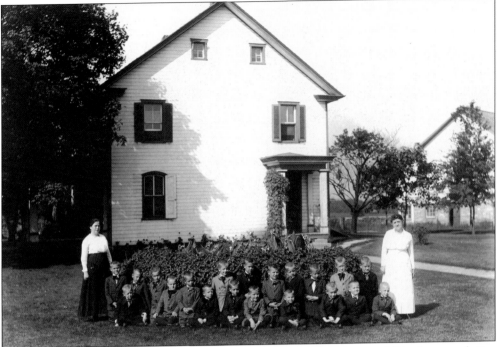

KINDERHAUS, 1915. Kinderhaus farmhouse was built in 1817 by Israel Hershey, a relative of Milton. Milton purchased the house and farm in 1906 and it served as a student home from 1912 until 1996. Today Kinderhaus is home to the Milton Hershey School Heritage Center and Department of School History.

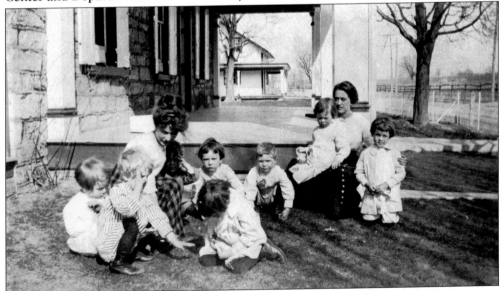

KINDERHAUS, c. 1915. According to Arthur Whiteman '27, "Up in the morning at six o'clock. After everybody washed and dressed, we gathered in the little hall at the head of the stairs to recite morning prayers and sing a hymn before coming down to breakfast. We had a playhouse just a few steps from the house where we lived . . . we could play on the porch or inside, just as we liked."

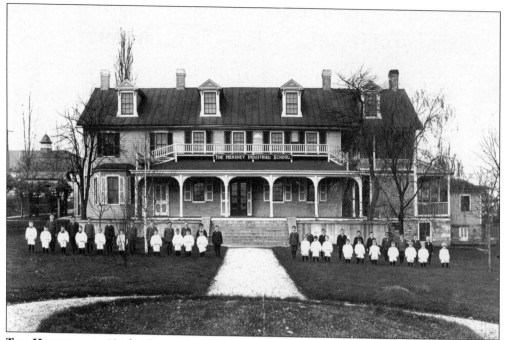

THE HOMESTEAD, 1914. The early years at the Homestead were a special time for the boys of the Hershey Industrial School. Many of the students have fond memories of the Copenhavers and the lessons George Copenhaver taught them in the large room at the west end of the Homestead, which had once served as Henry Hershey's library.

ALUMNI MEMORIES, LIFE AT THE HOMESTEAD. According to Guy Weber '23, "The thing I remember best is the homelike atmosphere and Mr. and Mrs. George Copenhaver." Nelson Wagner '22 recalls, "I have a lot of pleasant memories of the Homestead. It was in the Homestead that we lived [and] got our education—spiritual, mental, and physical."

THEN AND NOW, THE HOMESTEAD, 1915 AND 2007. In 1915, the Homestead served as the educational and administrative center of the Hershey Industrial School. In continuous use since its original construction in 1826, the Homestead underwent an extensive renovation before reopening in 2007 as an educational space devoted to the interpretation of the values of Milton and Catherine Hershey and the rich history and traditions of the Milton Hershey School.

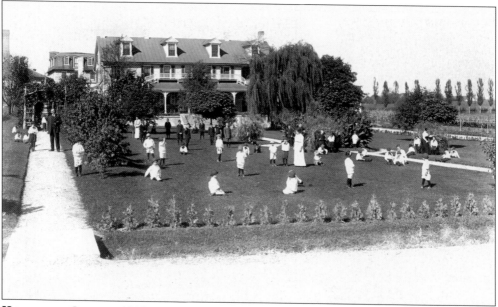

HOMESTEAD CAMPUS, 1915. By 1915, the population of the school had reached 60 boys. It was no longer practical to have them all photographed on the steps of the Homestead or to continue having them live with the Copenhavers. With additional farmhouses and outbuildings being converted to use by the school, the last students moved out of the Homestead in January 1918.

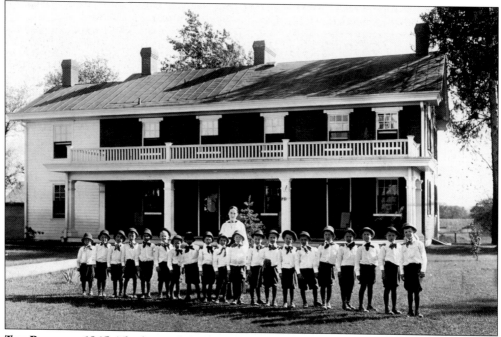

THE PRIMARY, 1915. The beautiful old Gingrich home, located across the street from the Homestead, became the Primary (for the primary grade students) in 1914. The Primary received the boys from Kinderhaus before they moved onto the Homestead. Anna Kendig served as governess with 20 boys under her care.

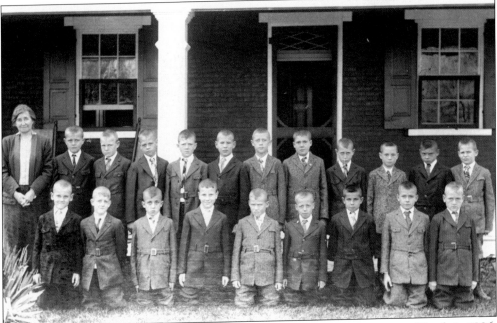

THE PRIMARY, 1918. According to the *Description and Outline of Courses of Study* in 1926, "Upon admittance to the School each boy is supplied with a quantity of clothing sufficient to his needs. After admission, the boy gets each year: 1 suit, 2 pair trousers, 2 pair Sunday shoes, 2 pair weekday shoes; overcoats every two years; sweaters every three years, and other underclothes as needed. All boys have their names on their clothes."

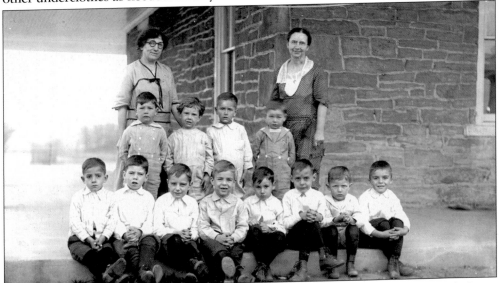

BUENA VISTA "DEPARTMENT B," 1916. When it became obvious that Homestead, Kinderhaus, and the Primary were becoming too overcrowded, the school decided to renovate three existing buildings. The first to be renovated was another stone farmhouse, which Hershey named Buena Vista. It sat on a small hill which may have reminded him of a similar location in Cuba—a favorite visiting place where he also held extensive business holdings.

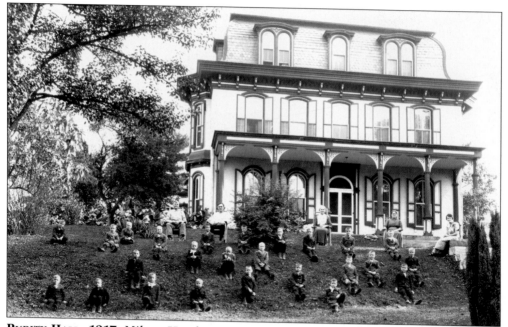

PURITY HALL, 1917. Milton Hershey purchased this property in the small village of Harpers (about 12 miles from the Homestead) in 1917. He planned to build a trolley line to connect this and several farms between Harpers and the town of Hershey. He also thought the large home would make an excellent hospital in the event an epidemic required students to be quarantined for any length of time.

HARPERS, C. 1918. The rural location of Purity Hall made it an excellent location for the smaller boys of the school to grow and play. The school quickly renamed the home Harpers and converted the adjoining carriage house into classroom space for the third and forth grade boys. Because of its distance from the rest of the school, Harpers was discontinued as a student home in 1938.

THE MAIN, 1930s. In 1917, Milton also remodeled the complex of buildings to the north of the Homestead (the original buildings of his Experimental Plant) into a combination dormitory and central services facility. The new building included a central kitchen, canning and processing room, bakery, and dining room, as well as a sewing and fitting room for clothing, repair shops for equipment, and dormitory space for students. The *Hershey Press* noted, "The dining room was finished in white enamel and mahogany and the reading room in like manner but with oak in place of the mahogany. The chief attraction (was) the central kitchen where all of the meals for the various departments of the school were prepared and sent out on a truck. The dormitory rooms were arranged so that there were from one to five beds per room." In time the building became the "Main" central receiving and shipping facility for the entire school. In January 1918, the last boys moved from the Homestead into the Main.

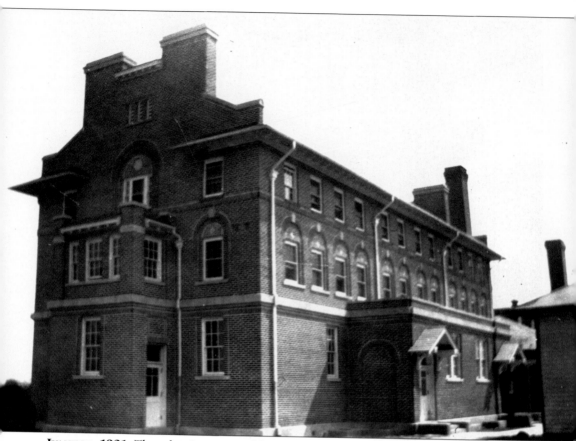

IVANHOE, 1921. The adaptive reuse of farmhouses and outbuildings only served to delay the inevitable. The school still had no central assembly space or a library. The classrooms located in the converted barn were now dilapidated and overcrowded. To compound the problem, enrollment topped 100 students for the first time in 1919, due in part to the battlefield casualties of World War I and deaths resulting from the 1918 influenza pandemic. A new facility designed specifically to meet the needs of the school was desperately needed. Milton Hershey and George Copenhaver differed on what a new facility should look like and how students in it should be housed. Hershey wanted the boys to continue to live in home-like farm house settings. Copenhaver believed that it would be more efficient to house students in dormitories similar to that used in the Main. The compromise was Ivanhoe—a three school-room, two-floor dormitory combination. Ivanhoe opened in September 1921.

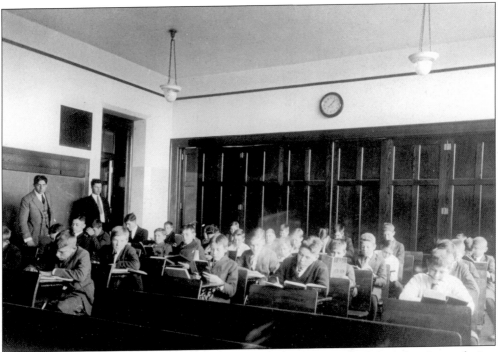

IVANHOE CLASSROOM, 1920s. As more boys entered the school and the school population began to age, both Hershey and Copenhaver recognized the need for male father figures for the boys. Male teachers in Ivanhoe also served as dormitory proctors.

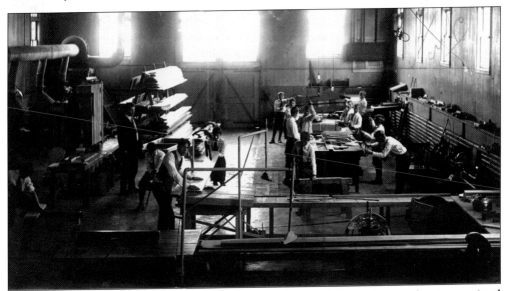

WOODWORKING CLASS AT THE MAIN, 1920s. Hershey and Copenhaver also recognized the challenges of keeping the older boys in the school "profitably occupied." Students who completed the eighth grade entered the public school to complete their vocational and academic studies. The first two Hershey Industrial School students graduated from Hershey High School in 1921. The Hershey Industrial School would not have its own high school until 1934.

STUDENT HOME CAABA, 1926. Throughout the 1920s, housing for students continued to be a pressing need for the growing school. In 1925, enrollment passed 175 students and in 1927 topped 200. The decision to house students only in cottage-style homes resulted in the construction of four units (Caaba, Dauphin, Evergreen, and Fosterleigh) to the north of the Homestead. Caaba, the first unit, opened in July 1926.

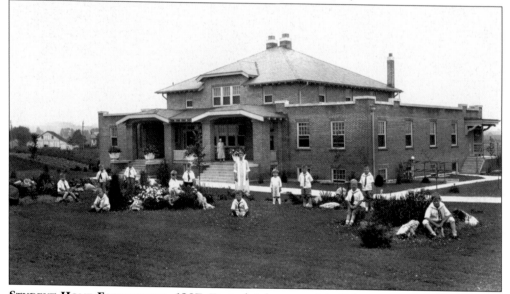

STUDENT HOME FOSTERLEIGH, 1927. Fosterleigh opened in February 1927 as the last of the four cottage homes. Appropriately enough for a school, these homes became known as the C-D-E-F homes for the first letter of their names. Each home was designed to accommodate up to 40 boys under the supervision of four women or matrons. Today they serve as transitional living homes for members of the senior class.

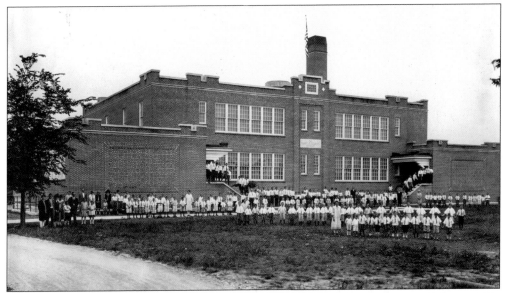

MEMORIAL HALL, 1927. To accommodate the growing need for classroom and assembly space, the school opened the Fanny B. Hershey Memorial School in July 1927. The building, a gift from Milton Hershey in memory of his mother, was located adjacent to the Homestead. The building contained eight classrooms, an assembly hall, and an indoor swimming pool—the first elementary school in the nation to include an indoor pool.

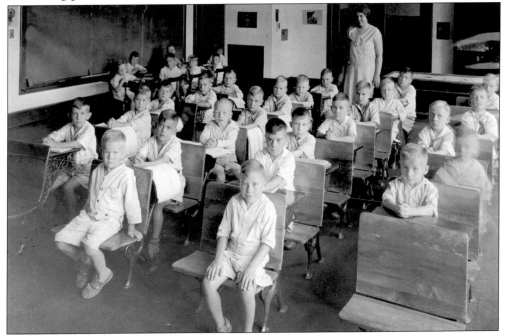

MEMORIAL HALL CLASSROOM, C. 1930. Mrs. Batdorf's combined kindergarten/first grade classroom was typical of the modern and well lit spaces found throughout the new educational facility where all students from kindergarten through eighth grade could be taught in the same building. The dedication of the facility in September 1927 included addresses by Gov. John Fisher of Pennsylvania and Milton Hershey.

TRUCK PATCH, 1910–1919. To Milton Hershey and George Copenhaver, classroom and vocational learning were only part of the educational process. To help students develop a sense of responsibility, they instituted a chore program. Their goal was to develop responsible students who would someday become responsible citizens. As part of the chore program each boy, except the very youngest, worked in the truck patch.

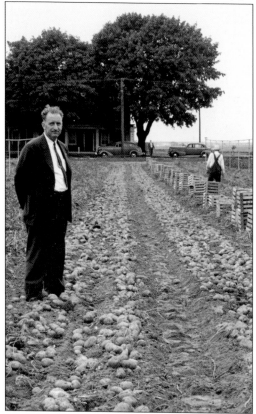

JOHN DANIEL, 1938. Guided by John Daniel, brother of Prudence Copenhaver, the boys grew a variety of fruits and vegetables to be used in the school kitchen or canned for future use. In one especially abundant year, George sold the excess and purchased a Victrola for the boys. The success of the truck-patching program helped convince Hershey to move the older students onto dairy farms in 1929.

Three

FAMILY LIFE IN
THE COUNTRY
1929–1950

In the 20 years since Milton and Catherine Hershey had signed the deed of trust, their school had grown from an enrollment of 10 boys in 1910 to nearly 250 boys in 1929. Expansion had been facilitated by Milton placing the bulk of his fortune—$60 million worth of Hershey Chocolate Company stock—in trust for the benefit of the school in 1918. Partially as a result of the economic devastation brought on by the Great Depression, the decade of the 1930s would see a dramatic increase in enrollment as the student body grew from about 300 in 1930 to over 1,000 in 1937; growth that would soon fuel changes in programming and present new challenges for the boys and their caregivers.

As enrollment grew and the boys already admitted to the school aged, it became increasingly difficult to keep everyone busy with meaningful work. Doing chores in the student home, working in the truck patch, or participating in organized sports occupied some of their time, but what was needed was a consistent program to challenge students and add to their understanding of life. To Milton, the solution lay in placing the older boys, those in grades 6 through 12, on area dairy farms that he used to produce milk for the chocolate factory. The first three of these student farmhomes opened in March 1929.

Milton's plan to provide for a type of family life in the country was perhaps modeled on his own experiences as a boy living on a farm in Nine Points, Lancaster County. While placing boys on the dairy farms had the added benefit of providing male role models for the growing boys, it also presented a distinct logistical challenge by splitting the home program of the school in two, since the older boys living in the farm homes lived under the administration of the Hershey Farm Company. While mostly well-intentioned, employees of the Hershey Farm Company were skilled farmers and dairymen and not necessarily trained or interested in nurturing adolescent boys.

As the economic uncertainty in the country deepened, Milton felt it was his responsibility to somehow help. In September 1933, he changed the deed of trust to allow a boy to qualify for admission if either parent, not just the father, were deceased and to allow boys

up to the age of 14 to be enrolled. Milton also took it upon himself to embark upon a massive building and public works campaign to benefit his community. The school also benefited from this increase in construction activity, opening 41 new student farmhomes between 1929 and 1941 and a combined junior senior high school building in 1934.

The construction of the Junior-Senior High School Building in 1934 was a crowning achievement for George Copenhaver who had always envisioned creating a strong vocational program within an academic setting. The completed building included ample shop and classroom space and became the administrative center for the school. D. Paul Witmer, an architect and builder as well a close personal friend of Milton, was responsible for the design and construction of the building. When Copenhaver passed away in February 1938, Milton asked Witmer to take over as superintendent, a position he held until 1951. Milton himself passed away on October 13, 1945, at the age of 88. Milton's funeral was held in the auditorium of the Junior-Senior High School with boys from the school serving as pallbearers. He was buried in the Hershey Cemetery next to his wife and parents.

At the time of his death in 1945, Milton left no heirs; however, he did leave an established legacy and a firm sense of direction for the school, the town of Hershey, and the various industries, which he had created. Though the old guard was passing, many of those who would shape the future direction and development of the school were already on board. One man in particular would play a critical role in seeing the school reach its full potential. John O. Hershey (not directly related to Milton) came to the school in 1939 with his wife, Lucille, as a houseparent. He would come to learn the school from the bottom up, understanding the strengths and challenges of the school and the farmhome program better than anyone else. He eventually succeeded Witmer as superintendent in 1951 and would remain as superintendent (and then as president) until his retirement in 1980. The seeds of modernization and transformation had been sown.

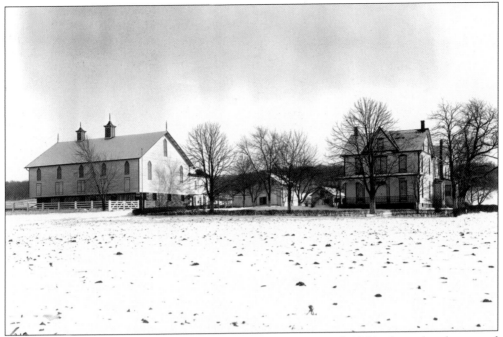

STUDENT FARMHOME GRO-MOR, 1929. Between 1929 and 1941, the school opened 41 farmhomes where boys in grades 6 through 12 lived and, as part of their chore program, milked cows. Gro-Mor (Farm 37A), Brookside (Farm 26A), and Meadowbrook (Farm 27A) were the first three to open in March 1929. All three were remodeled and expanded farmhouses located on dairy farms already owned by Milton Hershey.

MAURICE MILLER, PHILLIP CASE, FRANK PIPER AT GRO-MOR, C. 1933. Though farms on which the boys lived looked very much like family farms, they were in reality operated as a business by employees of the Hershey Farm Company. Two couples ran each farm and were referred to as either "First Help" or "Second Help," emphasizing their role in running the farm and taking care of the herds.

GRO-MOR DAIRY BARN, LATE 1940s. Barn chores included milking cows twice a day, cleaning stables, feeding stock, and maintaining the dairy in a clean and sanitary condition so that the milk collected from cows was untainted with bacteria. In the summer, the older boys worked as men in the field.

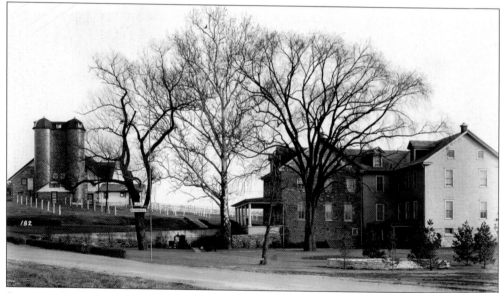

STUDENT FARMHOME BLOOMINGDALE, 1932. Bloomingdale (Farm 40) was the home where John O. and Lucille Hershey were first assigned as second help when they came to the school in January 1939. Couples placed in charge of a home were not generally referred to as "Houseparents" until the 1940s when John, as director of guidance, conducted the first formal houseparent training classes in an effort to provide support and establish uniform guidelines for running a home.

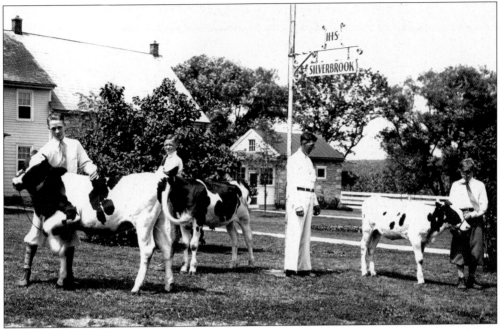

STUDENT FARMHOME SILVERBROOK (FARM 43), 1930s. Until the 1960s, the school had no formal policy for naming homes, and where names came from is not recorded. Some were most likely named for nearby topographical features (Silverbrook or Valley View) while others simply kept the "gentlemen farm" name already given to them by Milton Hershey (Gro-Mor or Cloverdale), or referenced literature (Arcadia), or travel (Venice).

FIRST BOYS AT STUDENT FARMHOME BONNIEMEAD, 1935. Milton did not make the decision to place his boys on farms lightly. He placed P. N. Hershey (a distant relative and head of the Hershey Farm Company) in charge of the dairy farm home program. Between 1929 and 1955, it was not uncommon to have 18 to 24 boys in grades 6 through 12 all in one home.

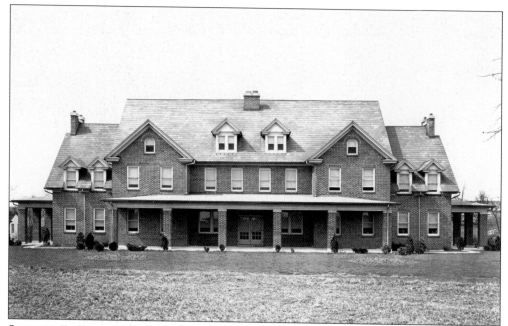

STUDENT FARMHOME WILLOW WOOD (FARM 28), 1931. On farms without a farmhouse or with a house that proved to be impractical to expand, the school built a large brick two-story home. All were based on a similar floor plan. The living apartments for the couples who ran the farm and home were placed at either end.

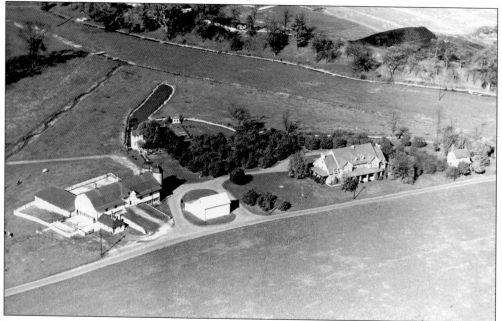

WILLOW WOOD AERIAL, 1930s. The two couples assigned to each home were also responsible for farming approximately 250 acres of land. Each farm grew a variety of crops to support a herd of 25 to 35 dairy cows. Farming was so integrated into the life of early students that many alumni even today refer to their student home by farm number rather than by name.

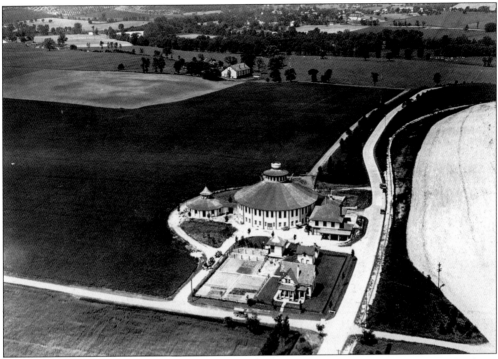

STUDENT FARMHOME BROAD ACRES (FARM 1), 1932. Milton Hershey was always looking for ways to improve the breeding lines and quality of milk produced by his herds, as well as the overall efficiency of his dairy operations. In 1913, he began construction of a round show barn where he could experiment with dairy feeds and breeding programs, demonstrate modern equipment and production methods, and sell milk and other dairy products to the public. At this site, student farmhome Broad Acres opened in 1932. In 1943, the Round Barn burnt down and was never rebuilt. Because the home did not have a barn it was used as an alumni house in the 1940s and as a home for graduating students who attended the Hershey Junior College in the 1950s.

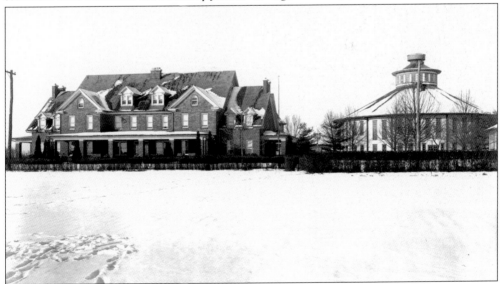

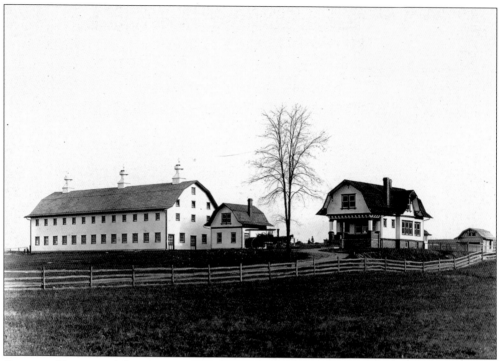

STUDENT FARMHOME CLOVERDALE (FARM 30A), 1931. Bolstered by his success in the breeding program in the Round Barn at Broad Acres, Milton Hershey soon envisioned the construction of a new barn devoted entirely to improving his herd of registered dairy cows. Work began on the large-two story barn and adjacent cottage soon after completion of the Broad Acres complex in 1914. The cottage served as the breeding supervisor's home, Hershey Farm Company headquarters, and repository for the breeding and registration records for the entire herd of Hershey dairy cows. The close interrelationship between the Hershey Farm Company and school was reinforced with the opening of student farmhome Cloverdale (below, right) in 1931.

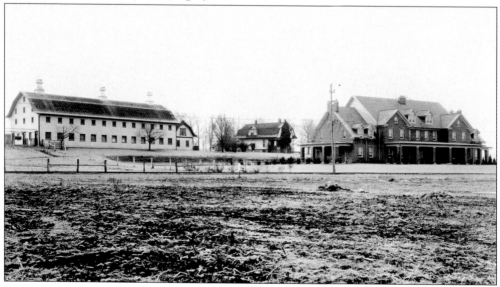

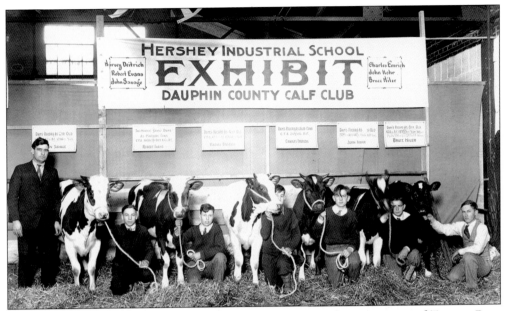

CALF CLUB, 1930 AND 1931. According to *Silver Brook: The True Story of Twenty Boys on a Farm Home of the Hershey Industrial School*, by Richard F. Seiverling '38, "On the farm you will learn to plow, to plant, to cultivate, to harvest, and to take care of animals. All of you will take your turns in the barn so that you will know how to milk a cow by the time you leave the School. Mr. Hershey wanted all of you boys to learn how to use your hands as well as your brains. He doesn't intend to make farmers out of you, but he feels that everyone should learn to appreciate the laws of nature. One of the best ways to do this is to work with animals on the farm."

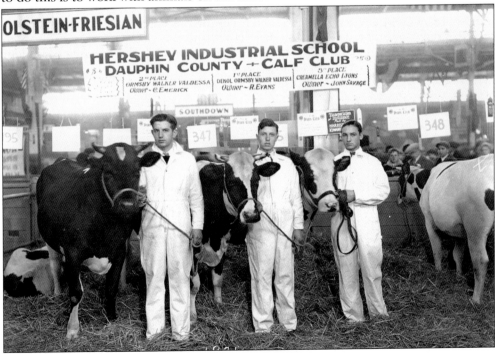

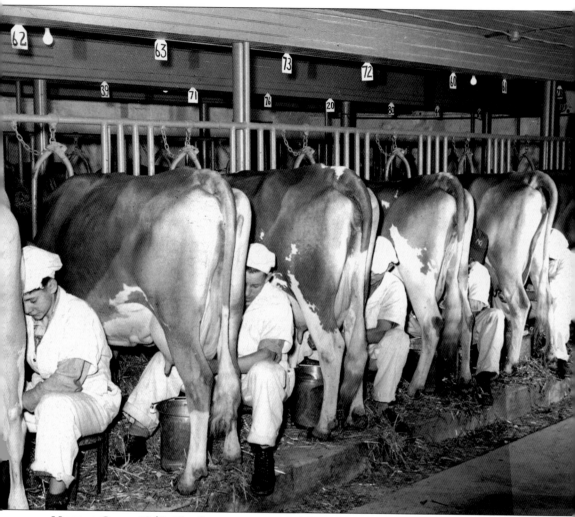

MILKING COWS, 1949. The farm program and the schedule for planting, harvesting, and milking dictated the daily and seasonal life of the school. Students in the farm home were given only 12 days for a summer home visit. The chore schedule was divided between house and barn duty. The daily schedule varied little from day to day or month to month.

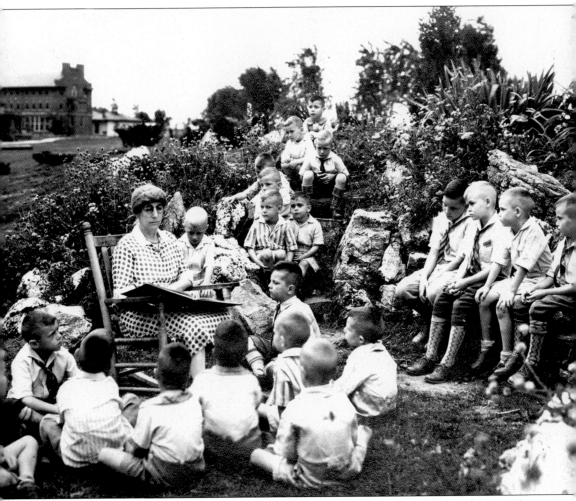

STORY HOUR AT FOSTERLEIGH, 1930. As the school grew and the older boys were moved out to the farm homes, the younger boys in the Junior Division (grades kindergarten through fifth) continued to live in the cottages in and around the Main. Because the philosophy of the school dictated that students remain on campus as much as possible to profit from the academic and home life program, even the younger boys were only allowed 12 (later 14) days for a summer home visit. Home visits for all boys of the school for holiday celebrations such as Easter, Thanksgiving, and Christmas were typically not granted by the school. The daily schedule varied very little; the chore program for the younger boys focusing on working in the home and in the truck patches.

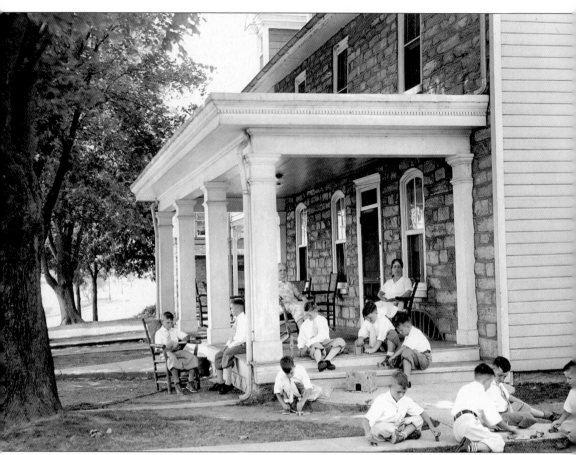

KINDERHAUS, 1930. By 1930, Kinderhaus housed only fourth and fifth grade boys. In his book *The Homeboy*, Rev. Dr. Clark E. Hobby '47 recounts, "I was happy at Kinderhaus. I liked its location, and I liked the people who were in charge. We could not have had better supervision. When we sat on the front porch, we were able to observe the traffic on Governor Road; also, the trolley care ran past our house on its way to Campbelltown. There were evenings when we were ready for bed, and Miss Barker would announce to us that we were going to be given a treat; she would invite us into her apartment, where we would sit on the floor in front of her radio and listen to one of our favorite radio programs—*The Shadow*."

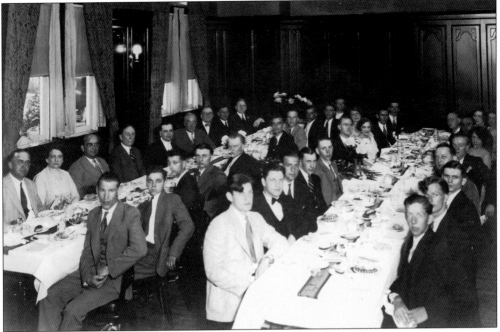

FIRST ALUMNI ASSOCIATION MEETING, 1931. In 1929, George Copenhaver discussed the possibility of forming an alumni association with several former students. Receiving favorable replies, he organized the first activity; a banquet held in the Walnut Room of the Community Center in June 1931. Milton Hershey is seated on the far left side and fourth from the wall.

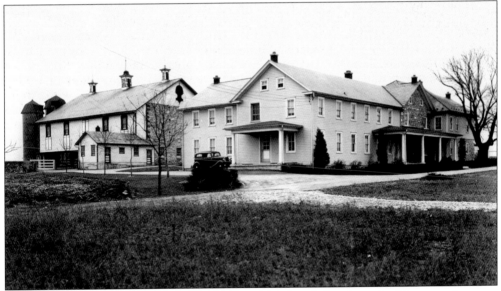

STUDENT FARMHOME BORDERLAND (FARM 45), 1933. Borderland received its name because the property straddled the Dauphin/Lebanon County line. The original name of the home was Recourse, the name apparently chosen because of the number of boys placed there who were being given one last recourse—or opportunity—to change their ways if they were to remain in the school.

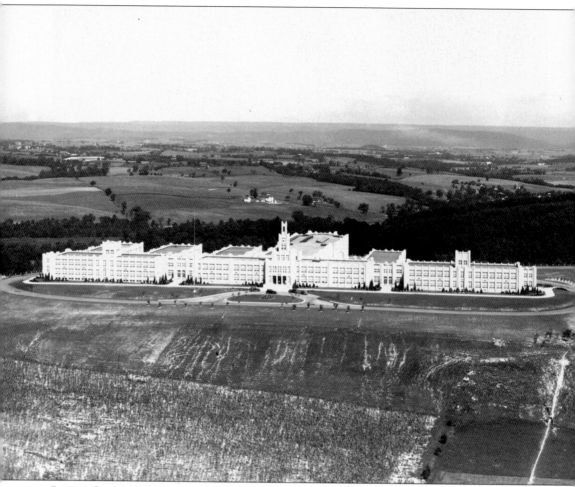

Junior-Senior High School, 1934. With enrollment on the rise during the early years of the Great Depression and with the cost of building materials at an all-time low, Milton Hershey decided the time was ripe to construct the long-awaited combined junior-senior high building for boys in grades 6 through 12. Catherine Hershey originally conceived of the idea of locating the school on top of the hill overlooking the town to the north; however, her premature death in 1915 prevented her from seeing the fulfillment of her dream. Milton made sure the building would accommodate the needs of the school well into the future by designing it with a capacity of 1,500 students; this at a time when total enrollment was less than half that number. Dedication took place November 15, 1934, as part of the 25th anniversary of the signing of the deed of trust in 1909.

DEDICATION, 1934. Milton briefly spoke at the dedication ceremony held in the building's new auditorium. His remarks included his belief that "men of wealth should give of their money for the betterment of their fellows, for they cannot take their wealth with them when they cease to exist here."

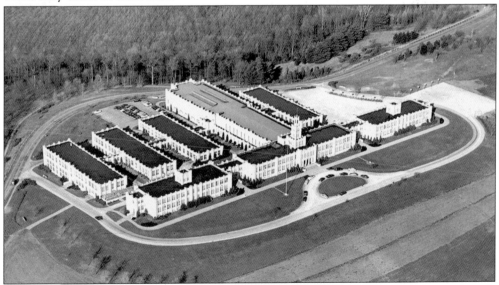

JUNIOR-SENIOR HIGH SCHOOL, 1940. The completed facility measured 780 feet in length and actually consisted of 13 interconnected buildings (five for academic support and eight for vocational shops) as well as administrative space, an auditorium that could seat 1,574 and a gymnasium with a capacity of 3,000. It took a year and a half to construct at a cost of $2.5 million.

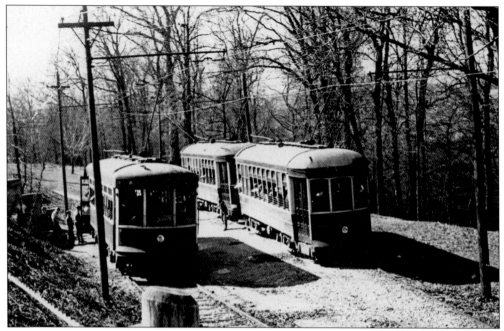

TROLLEY TUNNEL, 1930s. As the campus grew, students needed to be moved quickly and efficiently between student homes and the school north of town. Until 1946, trolleys brought students to a tunnel on the side of the hill which ran under the road between the trolley tracks and the building.

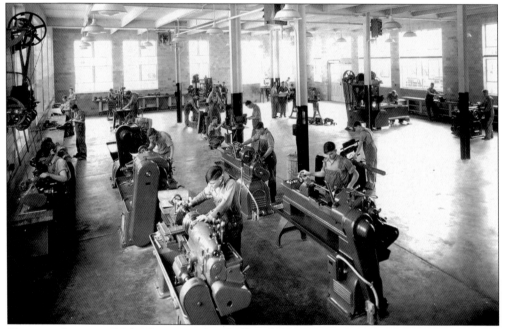

MACHINE SHOP, C. 1934. The new school offered three major courses of study: academic, commercial, and vocational. When the Junior-Senior High School opened in 1934, there were six trades to choose from: ceramics, electricity, woodworking, machine shop, printing, and plumbing.

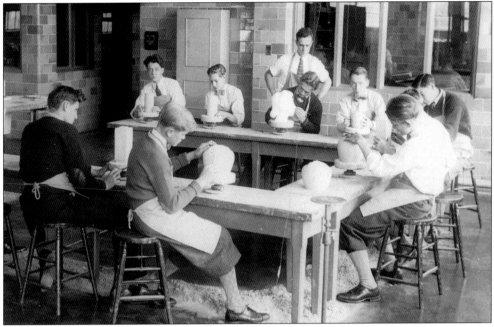

CERAMICS SHOP, C. 1934. The vocational courses available to students have changed over the years as technology and career opportunities have changed. On at least one occasion, even Milton Hershey had to accept change. It was he who insisted on including ceramics in the vocational program; however, the program was discontinued after only a few years for lack of interest among students.

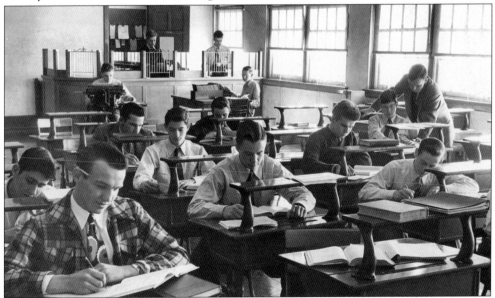

COMMERCIAL BUSINESS CLASS, 1949. John "Mac" Aichele '39 came back to the school to teach business in 1944. While most students chose to enroll in the vocational course of study, selection of a vocational program did not mean exemption from classroom instruction. In fact, vocational students alternated between classroom and trade instruction every two weeks.

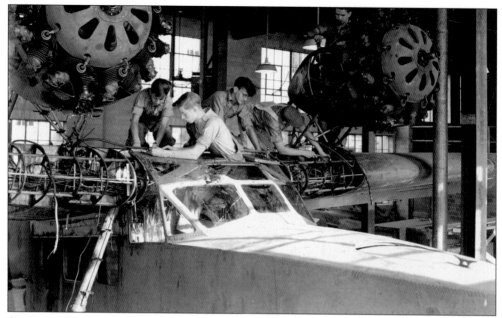

AIRPLANE MECHANICS IN THE AUTO SHOP. The first major addition to the program of vocational study occurred in the fall of 1935 with the addition of an automobile repair shop. The shop began with a single Model T Ford that was "torn down and reassembled from time to time," but quickly moved onto more diverse and challenging projects, including aircraft engine repair.

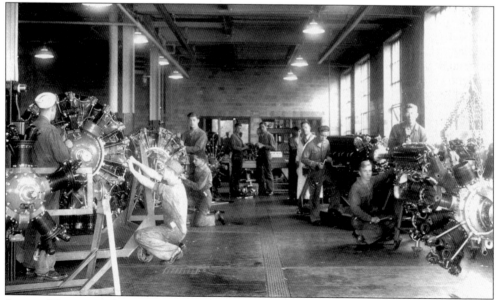

ALUMNI MEMORIES, AIRCRAFT ENGINES. According to John King '41, "The highlight of those four years [as an auto mechanic student] occurred after the U.S. Navy gave our School a nine-cylinder radial aircraft engine for training purposes. After removing and replacing a cylinder and timing the magnets, we were rewarded by a chance to operate this powerful engine. The noise and vibrations could be heard all over the school and attracted a big crowd of kids who at the time wished they were auto mechanics."

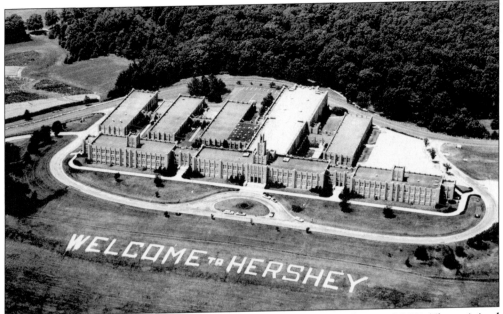

THEN AND NOW, JUNIOR-SENIOR HIGH SCHOOL BUILDING, C. 1962 AND 2007. The original "Welcome to Hershey" sign first appeared in front of the Junior-Senior High School for Parents Weekend in May 1960. The temporary sign proved so popular that it was recreated in stone in 1962 where it remained until removed in 1974. When the school constructed a separate middle school in 1966 named Catherine Hall in honor of Catherine Hershey, the Junior-Senior High School was renamed Senior Hall. Senior Hall served as the senior high school for grades 9 through 12 until 2000. Following a complete renovation and renewal, the former Senior Hall reopened in August 2007 as a middle school, assuming the name Catherine Hall. In anticipation of this grand reopening, the stone sign was painstakingly recreated to its former appearance; returning the popular landmark to its rightful place overlooking the town built on chocolate.

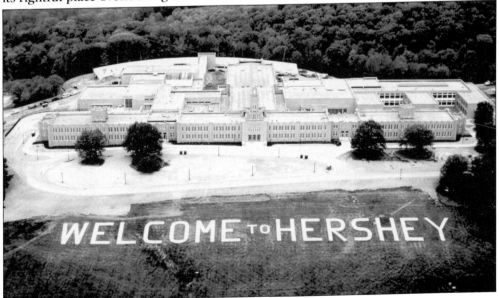

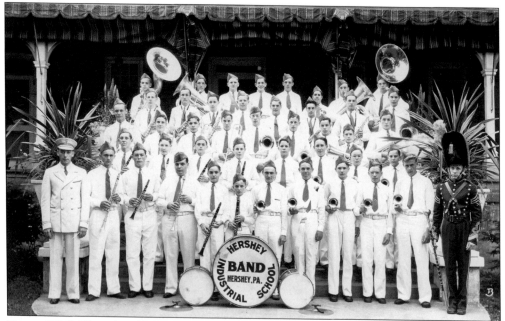

Band, 1926. The school band gave their first public performance on November 11, 1926, at the Armistice Day (now Veterans Day) exercises held in the Hershey High School auditorium. This photograph of the band is taken on the steps of the Homestead.

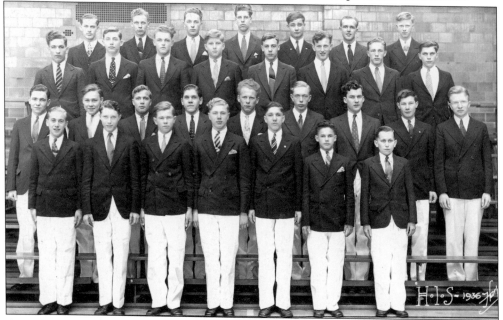

Glee Club, 1936. Membership in the Glee Club recognized outstanding personal and academic achievement as well as demonstrated musical ability. The Glee Club participated in choral competitions, presented programs in churches and school, and traveled throughout Pennsylvania and nearby states. The group received frequent national recognition for its efforts, appearing at the White House Conference on Children and Youth in 1960 and the New York World's Fair in 1965.

66

BASKETBALL, 1923. Basketball was the first organized sport at the school. Pictured here are members of one of the earliest school sporting teams taking a break from practice. Athletics have always played an important role in helping students feel a sense of accomplishment and pride in their school.

BASKETBALL, 1938–1939. This team might be best remembered for the future accomplishments of two of its players. William Dearden '40 (seated, second from left) would become chief executive officer and chairman of the Hershey Company. John McClellan "Mac" Aichele '39 (standing, second from right) would become president and chairman of the Milton Hershey School.

INFIRMARY, 1938. When Milton and Catherine Hershey established their school in 1909, they took careful steps to provide a healthy pastoral environment, proper nutrition, and sound medical care for the boys. A growing school population and the reoccurrence of several influenza outbreaks—including the pandemic of 1918 that claimed the life of student Charles Swartz—convinced Milton of the need for a larger and better-equipped facility. In March 1933, the school opened a new two-story brick infirmary midway between the Homestead and Kinderhaus and on the opposite side of the road. In 1938, the school built student farm home Habana to the west (right side) of the Infirmary.

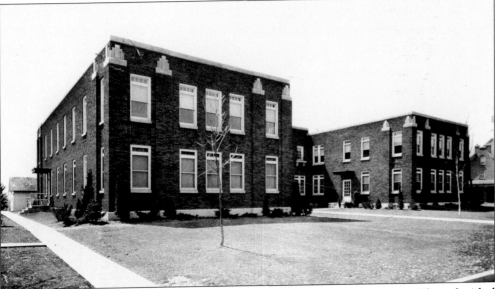

INFIRMARY, 1934. As the population of the community continued to grow, Milton decided to offer the use of the Infirmary to the town. In March 1941, the Hershey Community Hospital merged with the school Infirmary to form the Hershey Hospital. Milton Hershey died here on October 13, 1945. His first floor corner room afforded him a view of the Homestead only a few hundred yards away.

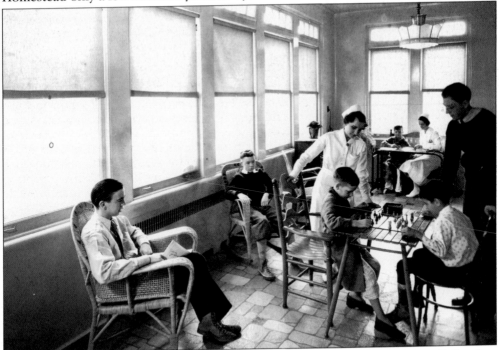

SOLARIUM, 1934. The town and school would share the hospital space until October 1970 when the Hershey Hospital was closed and patients transferred to the new Hershey Medical Center. At that time the facility became home to the Milton Hershey School Health Center.

69

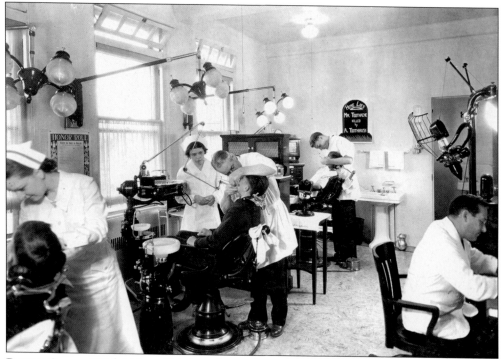

DENTAL CLINIC, 1934. Milton Hershey also took an interest in the dental health of the boys. Dr. W. E. Vallerchamp became the school's first dentist in 1919. Dr. Herbert Cooper (at desk) became director of the Dental Clinic in January 1934. Cooper would later become internationally recognized for his pioneering work in the treatment of cleft palate.

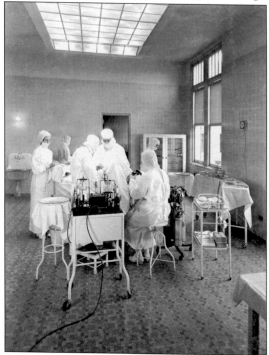

OPERATING ROOM, 1940s. To Milton Hershey, the sharing of staff and facilities between the school and town of Hershey not only made good economic sense, it also reinforced the interrelationship between the school and community which exists to this day. Many alumni, school employees, and town residents are quick to share "fond" memories of their time spent in the Hershey Hospital.

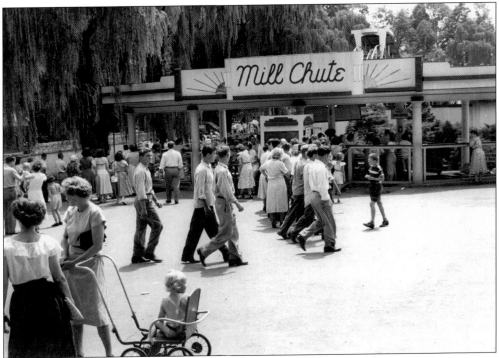

BOYS AT HERSHEY PARK, 1949. Activities considered "privileges" allowed boys a certain sense of freedom, fostered responsibility, and provided an outlet for creativity. Organized activities included glee club, choir, orchestra, band, interscholastic and farm-home league athletics, and Boy Scouts. General privileges included swimming, visiting with relatives, or taking walks. Town privileges allowed boys to attend movies and parties or to visit Hershey Park.

BOYS IN KNICKERS, 1930s. According to the *Official Handbook for the House-Parents of H.I.S*, 1946, "Each boy should be inspected when leaving the farm-home to see that he is wearing the proper clothing, and that his general appearance is neat. They should wear their best clothing to church and to any special activities. Boys should wear their school clothing to school and when going to town on regular privileges."

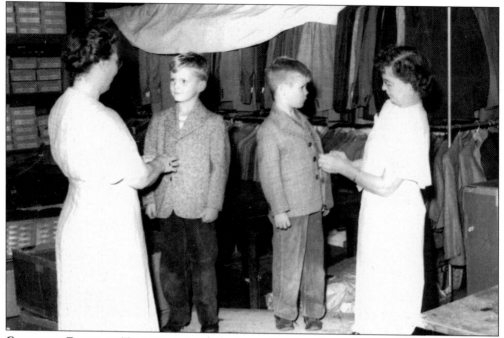

CLOTHING ROOM AT THE MAIN, 1940S. According to the *Official Handbook for the House-Parents of H.I.S,* 1946, "The fitting of some clothing is done in the clothing room; however, house-mothers are expected to do some fitting and altering in the home. Bulletins are sent from the clothing room from time to time giving specific and detailed information regarding the ordering and fitting of clothing."

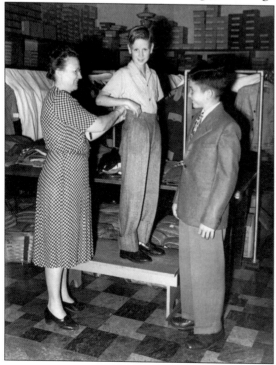

HELEN HARTMAN FITTING BOYS AT THE CLOTHING ROOM, 1949. All boys visited the clothing room each spring and fall for a fitting. Harry and Helen Hartman came to the school in 1922 as houseparents and remained closely involved in the daily lives of students until their retirement in 1959. After 73 years of combined service, Harry poignantly stated, "We will miss the boys because we lived their lives."

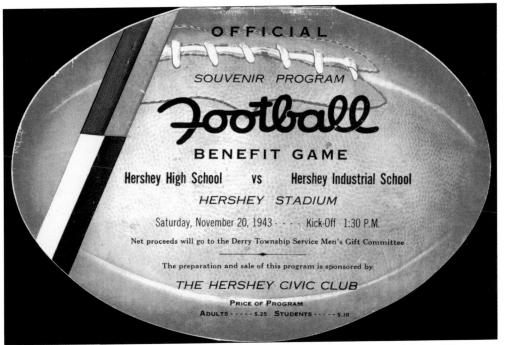

OFFICIAL

SOUVENIR PROGRAM

Football

BENEFIT GAME

Hershey High School vs Hershey Industrial School

HERSHEY STADIUM

Saturday, November 20, 1943 · · · · Kick-Off 1:30 P.M.

Net proceeds will go to the Derry Township Service Men's Gift Committee

The preparation and sale of this program is sponsored by

THE HERSHEY CIVIC CLUB

PRICE OF PROGRAM
ADULTS · · · · · $.25 STUDENTS · · · · · $.10

FOOTBALL PROGRAM, 1943. Every year since 1943, the Hershey Industrial School Spartans and the Hershey High School Trojans have met in the annual Cocoa Bean Game. The winner is awarded the Cocoa Bean Trophy which, because of wartime restrictions on metal, was originally an actual cocoa bean mounted to a wooden base.

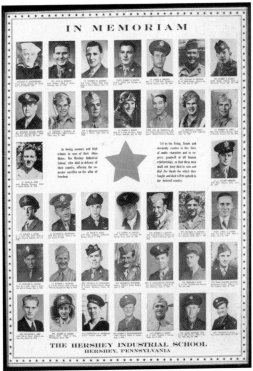

GOLD STAR ROLL CALL, C. 1946.
Graduates of the school proudly served their country during World War II in all branches of the military. School records indicate that over 1,000 (or 91 percent) of the 1945 roster of alumni served their country during the war. Regrettably a substantial number of these men also gave their lives in defense of their country.

73

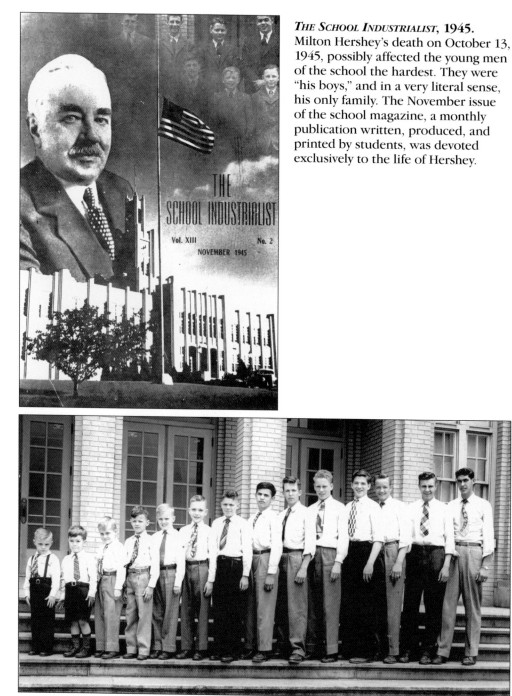

THE SCHOOL INDUSTRIALIST, 1945. Milton Hershey's death on October 13, 1945, possibly affected the young men of the school the hardest. They were "his boys," and in a very literal sense, his only family. The November issue of the school magazine, a monthly publication written, produced, and printed by students, was devoted exclusively to the life of Hershey.

THE SCHOOL INDUSTRIALIST

Vol. XIII No. 2

NOVEMBER 1945

STUDENTS OF THE HERSHEY INDUSTRIAL SCHOOL, 1950. In the 40 years since the first boys were first pictured on the steps of the Homestead, the school had been tested many times: surviving explosive growth during the 1930s, wartime restrictions during the 1940s, and the death of its founder in 1945. As the school looked to the challenges of the future, it was well positioned by Milton Hershey to meet the demands a changing society would soon require.

Four

SAME OL' SCHOOL
BUT A NEW NAME
1951–1980

Since the death of George Copenhaver in 1938, D. Paul Witmer had served as superintendent. Trained as an architect, Witmer never considered himself an educator and instead came to rely increasingly upon the advice of Dr. John O. Hershey. Witmer realized Hershey possessed many of the abilities, necessary education, and familiarity with the operation of the school that were needed to move the school forward. With Witmer's full support, Dr. Hershey became the new superintendent on November 1, 1951. Dr. Hershey believed that a whole new approach was needed on the farm, in the classroom, in the student home, and in the administration of the school if the needs of students were to be met in a satisfactory manner. To help set the tone of change, Hershey led the effort to change the name of the school from Hershey Industrial School to Milton Hershey School—a change which became official on December 24, 1951. In a letter to alumni titled "Same Ol' School But A New Name," Dr. Hershey noted that the new name would, "carry dignity, be practical, and be free of any words . . . such as vocational, training, institute, country, farm, technical, village, city, and town . . . which over a period of time could degenerate in meaning." Acceptance of the new name was no doubt made easier by the fact that both names consisted of three words (two of which were the same).

The appointment of Dr. Hershey as superintendent and the near simultaneous school name change ushered in a period of great energy and vision. New "homelike" furnishings in student homes and a new school flag, banner, alma mater, and promotional film helped fuel a growing sense of innovation and excitement. New ways of thinking led to some exciting new programs but also to some major restructuring and a growing conflict between classroom instruction, vocational training, and farm work. The 50th anniversary celebration in 1959 gave Dr. Hershey and the school the opportunity to assemble a committee of nationally recognized experts to access programs and recommend more fundamental changes. The recommendations of the Anniversary Evaluation Committee resulted in an explosion of programs and support services focused on the developmental

needs of students and a renewed emphasis on constructing facilities necessary to moving these programs forward. By 1970, the school would build or renovate over 100 student homes and construct a new middle school and new administrative center, known as Founders Hall.

Change was in the air, but the biggest challenges to affect the school were yet to come. Recognizing the evolving needs of American society, the school made the decision to allow nonwhite students to enroll in August 1968 and restated the deed of trust to reflect this change in December 1970. In November 1976, the deed was again modified to allow females and non-orphaned, or social orphan, students to be admitted to the school, providing they met the requirements of being poor and coming from families that could no longer adequately care for them.

The decision to admit girls and children who were not receiving adequate care at home forced the school to rethink policies and programs that had been in place since the school was founded. The arrival of girls was for the most part positive and well-received by the all male student population. The school would struggle a great deal more with the special needs and circumstances presented by social orphans. For the first time in its history, the school needed to be as concerned with the feelings and desires of parents and sponsors as they sought to take a more active part in the education and development of their child.

As Dr. Hershey prepared to retire in 1980, the school and its student body were far different from what they had been when he took over in 1951. Changes and advances in American society and educational theory had a profound affect on the school. Under Dr. Hershey's leadership, the deed of trust had been expanded to provide opportunities to more students and new programs and facilities had been constructed to better serve those students. His retirement was also symbolic of the change taking place in the administration of the school, as those adults who knew or worked with Milton Hershey were now of retirement age and the mantle of leadership passed to a new generation. It would be left to John McClellan "Mac" Aichele '39, the new president and first alumnus to head the school, to determine the direction the school would take in the years ahead.

D. PAUL WITMER, C. 1950. As a professional engineer and architect, D. Paul Witmer is best remembered for designing and constructing many of the most prominent buildings and homes in Hershey. As one of Milton Hershey's most trusted advisors and confidants, Witmer eventually served on every Hershey corporate board and as superintendent of the Hershey Industrial School from 1938 until 1951.

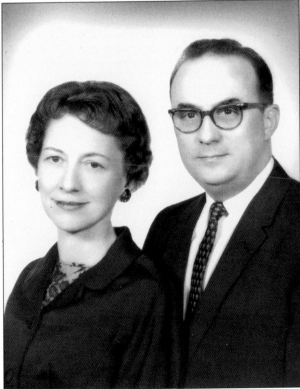

DR. AND MRS. HERSHEY, C. 1955. The Hersheys began their employment at the school in January 1939 as houseparents. Dr. John O. Hershey received his doctorate in education in 1948 and served as third superintendent (1951–1962) and first president (1963–1980). His wife, Lucille, added much to the social life of the school, especially when the Homestead became home to the president of the school in 1961.

Winter at Fort Linden, 1952. During the 1930s, the school opened 41 farm homes for boys in grades 6 through 12, but none for those in the elementary grades. To address issues of overcrowding in the homes for younger boys, the school looked to build four additional homes in the area between the Homestead and Kinderhaus. Continuing the tradition of naming the homes for younger boys in alphabetical order, Granada and Java opened in 1950—the letter "H" already taken by Homestead and "I" by Ivanhoe. Linden (pictured here) and Nassau opened in 1951—the letter "K" already taken by Kinderhaus and "M" by the Main.

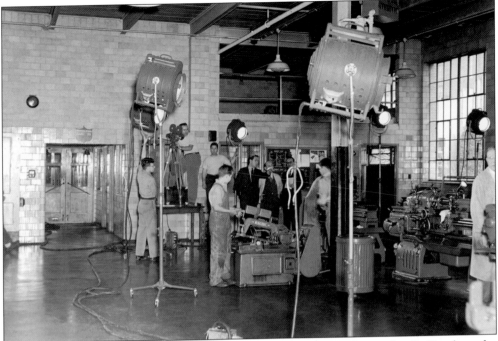

"A Living Heritage for Boys," 1952. Under the leadership of Dr. John O. Hershey, the admissions office embarked upon an aggressive campaign to contact communities and acquaint them with the opportunities available for children at the school. Hershey hired director Paul Wendkos and producer Louis Kellman (the same team who worked with Jayne Mansfield in her first starring role) to develop a promotional color film showcasing all the school had to offer.

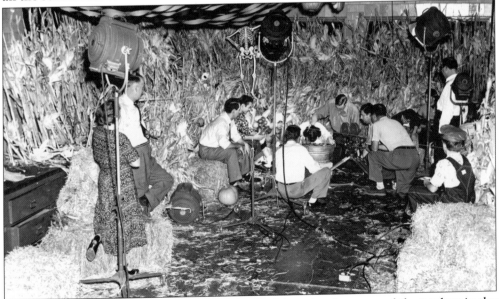

Bobbing for Apples, 1952. Students and staff of the school portrayed themselves in the film. The school released the movie in 1953 and made it available to schools, civic and church groups, and anyone else interested in showing it to potential students.

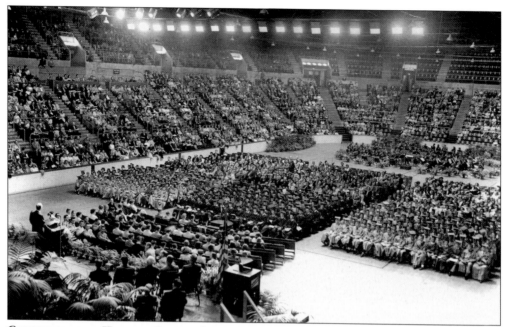

COMMENCEMENT, HERSHEY SPORTS ARENA, 1953. The 50th anniversary of the founding of the town of Hershey provided the occasion for the only joint commencement of Milton Hershey School, Hershey High School, and Hershey Junior College. Dr. Milton Eisenhower, president of the Pennsylvania State University and brother to Pres. Dwight D. Eisenhower, served as speaker. He was the first in a long line of distinguished speakers to address the graduating class.

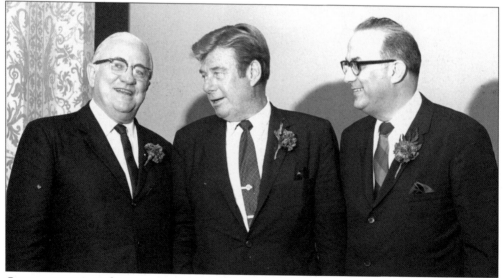

COMMENCEMENT, 1969. The school selected figures of national prominence as commencement speakers both for the content of their message and the increased exposure they gave to the school. In his address, entertainer and conservationist Arthur Godfrey (center) challenged graduates to do something about the many ecological problems facing the world; urging them "to learn to be part of our environment instead of trying to be masters of all."

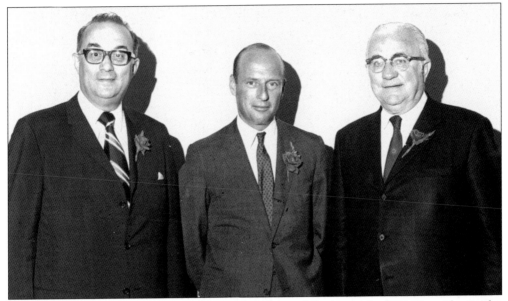

COMMENCEMENT, 1970. Capt. Charles "Pete" Conrad Jr. (center) of NASA spoke to the graduates about the importance of being loyal, patriotic, and productive citizens and developing "a spirit of service" to their fellow man. Conrad served as pilot on Gemini V and as commander of Gemini XI, Apollo XII, and Skylab II. Conrad is pictured with Dr. John O. Hershey (left) and James Bobb, chairman of the Milton Hershey School Board of Managers.

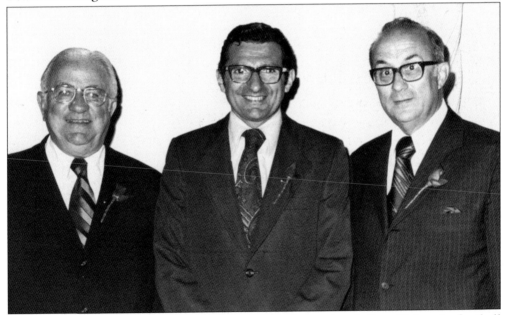

COMMENCEMENT, 1973. At the time of his selection, Pennsylvania State University football coach Joe Paterno had the highest winning percentage in the nation among major college coaches. The school selected Paterno as an inspiration to excellence and for his "uncanny ability to develop talents and positive character traits within young men so they succeed far beyond even their own expectations."

COMMENCEMENT, 1977. When asked why he decided to speak at the school, famed entertainer Art Linkletter, himself an orphan having been abandoned by his parents when only a few weeks old, replied, "I have never seen a better effort anywhere in the world to help young people build lives than at the Milton Hershey School."

COMMENCEMENT, 1979. Various elected officials, including sitting Governors William Scranton in 1963 and Dick Thornburgh in 1979 of Pennsylvania, helped to raise the awareness of the school in political and governmental circles. Thornburgh's selection coincided with the International Year of the Child. His remarks were recorded and later rebroadcast throughout the entire state by the seven public television stations of the statewide network.

FIRST ALUMNUS OF THE YEAR, 1954. As the school looked to the future it also looked for new ways to provide positive role models for students; instituting an Alumnus of the Year award in 1954. Arthur Whiteman '27, pictured below (right) in 1915, was the first recipient, coming to the school in 1913 at the age of four. Milton Hershey hand-picked him to work as an apprentice clerk in the Hershey Trust Company while still a student. In 1939, he was appointed to the Milton Hershey School Board of Managers, the first alumnus to be named to the board and the only one to hold that position during Milton Hershey's lifetime. He served on every Hershey corporate board and as president of the Hershey Trust Company before retiring in 1974 after 50 years of service.

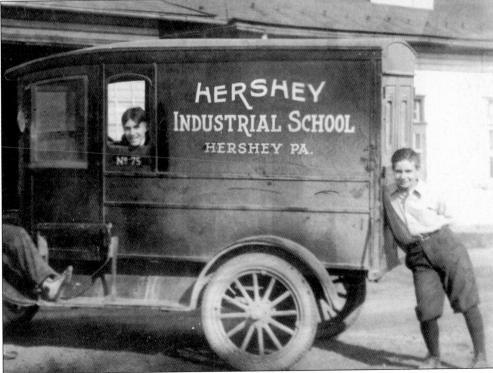

ALMA MATER

Milton Hershey School

"ALL HAIL TO THEE, MILTON HERSHEY; THY LOYAL SONS ARE WE," 1956. These are the stirring opening words of the new school alma mater adopted in 1956. The new song replaced an earlier Hershey Industrial School song written to the tune of *Anchors Aweigh*. Despite the popularity of the original, many in the school thought the military nature of the piece made it inappropriate for use as an alma mater.

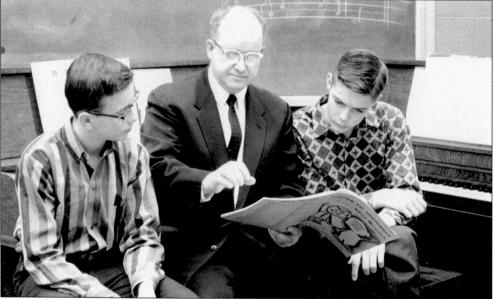

W. PURNELL PAYNE WITH MICHAEL QUICK '65 AND FREDERICK BRONSON '66, 1961–1962. In May 1950, the school formed the first of several working committees to investigate the writing of a new song. The finished product was largely the work of W. Purnell Payne, Spartan Orchestra director and chair of the school's music department and Virgil Alexander, director of the school's Glee Club.

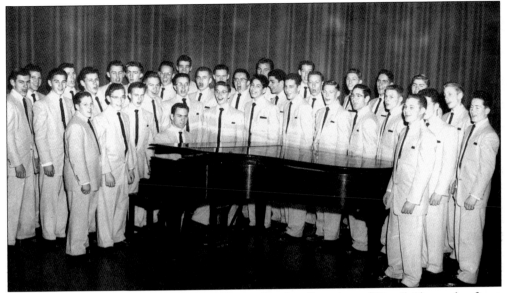

GLEE CLUB, 1954–1955. The Glee Club, under the direction of Virgil Alexander from 1953 until his retirement in 1985, made approximately 50 public appearances each year, varying from formal concerts to "rollicking" stage shows and for audiences ranging from social gatherings to national conventions. Because students served as ambassadors for the school, selection was based on outstanding personal and academic qualifications as well as musical ability.

GLEE CLUB, 1963–1964. Because of the variety of programs and occasions the group participated in, songs for each appearance were selected from a standard repertoire. All songs were memorized and each performance uniquely staged. In the 1985–1986 school year, the Varsity Choir replaced the all-male Glee Club.

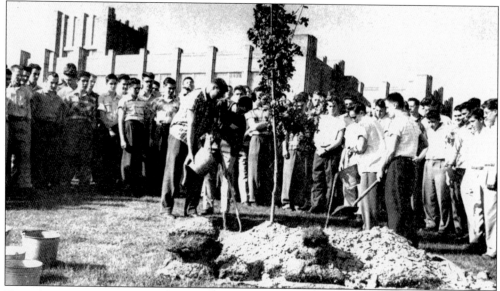

FIRST SENIOR CLASS TREE PLANTING, 1956. The tradition of planting an oak tree in honor of Milton Hershey began with the class of 1946. They made their presentation at the annual Class Day Exercises in the spring. The first class to present and plant their own tree on Founders Day was the class of 1957, which planted their tree on November 15, 1956.

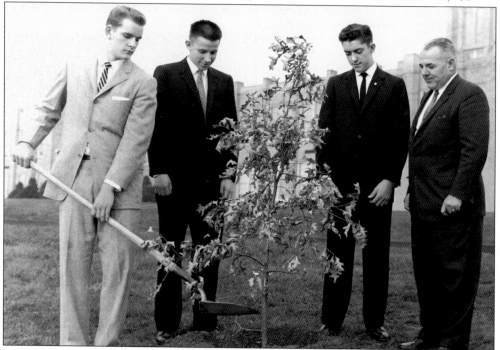

SENIOR CLASS TREE PLANTING, 1961. Hershey once said, "There is not a person alive who should not plant a tree—not for the shade that you'll enjoy, but for those who are coming after." Here, from left to right, class of 1961 president and past school president Johnny O'Brien, class officers Ronald Schaffer and Carlo Gilotte, and faculty advisor Frederick (Fritz) Miller plant their tree on Founders Day, November 15, 1960.

FARMHOME LIVING ROOM, 1956. Dr. John O. Hershey wasted little time in making student homes more livable and student programs more responsive to the needs of students. He instructed that comfortable upholstered furniture replace the solid wood tables, chairs, and benches that for so long characterized student homes and that curtains be hung at windows in place of blinds.

JUNIOR DIVISION COTTAGE LIVING ROOM, 1956. In June 1953, the school began installing black and white television sets in each student home. For those with an interest in music, the school began to purchase pianos for each student home in 1961.

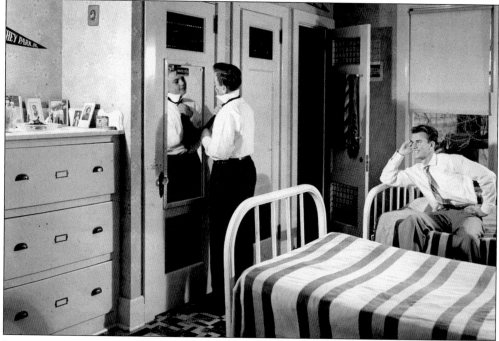

FARMHOME BEDROOM, 1956. During this period, bedrooms were also upgraded to provide students with more privacy as well as a sense of personal space and identity. Until the 1960s, studying in the evening was done at the tables in the dining room under houseparent supervision rather than in the bedroom. The overall effect was to provide students with a comfortable home setting for study, relaxation, and entertainment.

STUDENT HOME REC ROOM, 1956. The addition of recreation rooms, hobby areas, outdoor basketball courts, and even carports quickly led both farm homes and cottages to take on a much warmer and much more homelike atmosphere.

SCOUTING, 1953. Boy Scout Troop 75 was organized in May 1929. Cub and Girl Scout programs did not begin until 1977 when the first girls were admitted to the school. Currently all students in kindergarten through fifth grades must participate in scouting. In 1942, Milton Hershey received the Silver Beaver Award, bestowed by the Boy Scouts of America upon those who give truly noteworthy and extraordinary service to youth.

SANTA VISITS A JUNIOR COTTAGE, 1954. Prior to 1959, boys in the school did not go home during Christmas but instead remained at their student homes during the brief recess. While most boys received gifts from family, the school made sure that every student received at least one present. The school magazine from December 1933 noted that, "Mr. Hershey gives each boy a box of candy."

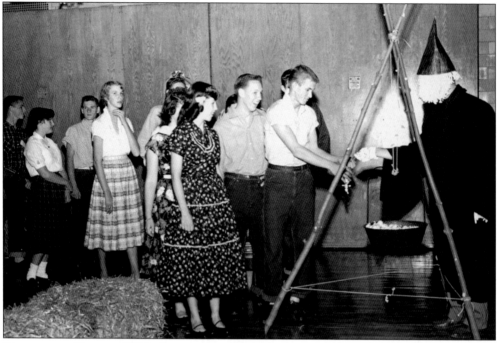

HALLOWEEN DANCE, 1959. Steps were also taken to develop the social skills of the boys. Because the boys attended an all-male school, many of them found themselves uncomfortable in mixed company, especially following graduation. According to the *Catalogue and Viewbook,* 1952, "Special effort is made to help each boy to feel at ease in social gatherings. The older boys have opportunities for dates with girls at community and school functions. These may include small parties either in the farm-homes or in a home of a private family in the local community, class parties and dances, and community functions sponsored by the public school, churches, or other community groups."

HALLOWEEN PARTY, 1950s. Boys in the Junior Division were exposed to less formal, but no less important, outlets for social interaction and fun both in the classroom and in the student cottage home.

JUNIOR-SENIOR HIGH SCHOOL, 1960s. Another facet of the program to improve the social graces of the students was the conversion of the school cafeteria into a dining hall. Dr. John O. Hershey developed and set in motion a plan to turn the noon lunch period into a training exercise in table etiquette where students and teachers sat together and served each other in a "family style" setting.

THE SCHOOL PLEDGE

I WILL KEEP MYSELF PHYSICALLY STRONG, MENTALLY AWAKE AND MORALLY STRAIGHT. I WILL TRY TO KEEP MY STANDARDS HIGH AND HELP OTHERS TO DO LIKEWISE. IN MY RELATIONS WITH OTHERS I WILL LIVE BY THE GOLDEN RULE. I WILL IMPROVE MY LANGUAGE WHICH IS A TRUE EXPRESSION OF MY CHARACTER. I WILL PLEDGE MYSELF TO HONOR, TO UPHOLD, AND TO DO ALL I CAN FOR THE GOOD OF MY SCHOOL. THESE ARE THE BEST SERVICES I CAN RENDER TO MY SCHOOL, MY COUNTRY, AND MY GOD.

THEN AND NOW, MILTON HERSHEY SCHOOL PLEDGE, 1952 AND 2003. The original school pledge, written by George Copenhaver in 1926, included the sentence, "I will help others to get the comforts of life and happiness which are rightfully theirs," in an effort to reduce bullying by the older boys. Over the years, the phrase became confusing and to some extent meaningless to the students. The 1952 version replaced that sentence with, "I will try to keep my standards high and help others to do likewise." The original pledge also made no reference to God, but instead ended with the phrase, "my school, my state, and my country." School president Johnny O'Brien '61 revised the pledge in August 2003 soon after taking office.

MHS School Pledge

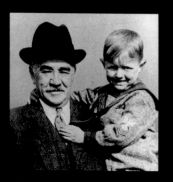

I will keep myself physically strong, mentally awake, and morally straight.

I will keep my standards high and help others to do likewise.

In my relations with others, I will live by the Golden Rule and will speak the truth at all times.

I pledge myself to honor, and to do all I can for the good of my school, my country, and my God.

THE *SPARTAN*, APRIL 1957. The student produced and printed publication, originally called the *School Industrialist,* contained articles, photographs, and even cartoons (like this one by Thomas McGruddy '57) on topics of interest to students. Hair length and style of haircuts were strictly enforced and the responsibility of Allen "Zookie" Zook. He started as the first regular full-time school barber in October 1931 and worked for 37 years, retiring in October 1968.

THE 50TH ANNIVERSARY CELEBRATION, 1959. During the academic year 1959–1960, the school hosted a variety of programs, events, and activities in honor "of fifty years of service to youth." Traditional annual activities like homecoming, parent weekend, and commencement were joined by special anniversary initiatives and the distribution of memorabilia designed to honor Milton Hershey and to encourage a wider understanding of his school and its programs.

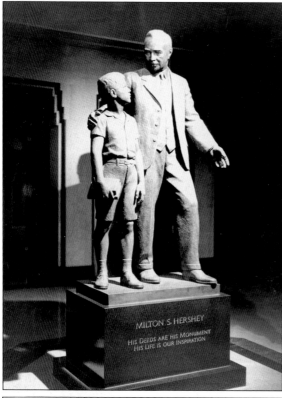

MILTON HERSHEY AND THE BOY, **1960.** This statue, by noted American sculptor Walker Hancock, was a gift to the school from the Milton Hershey School Alumni Association. Although part of the 50th anniversary celebration, the finished bronze life-sized statue was not placed in the entrance foyer of the Junior-Senior High School until October 1960. According to Hancock, the boy does not depict any particular student in the school.

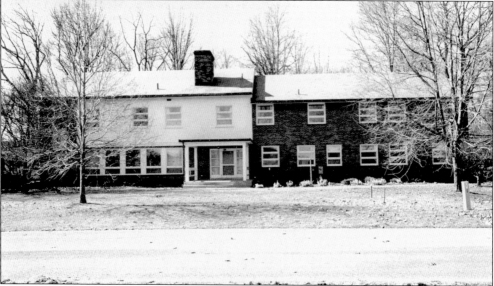

CEDARVIEW, 1961. The report released by the Anniversary Evaluation Committee in August 1960 directed growth and direction of the school for the next 10 years. Chief among its recommendations was the creation of an Intermediate Division to include a separate middle school and "small home units arranged in clusters of six to eight homes with fourteen boys in each home." Woodland cluster was followed by National, Keystone, Pennland, and Arrowhead.

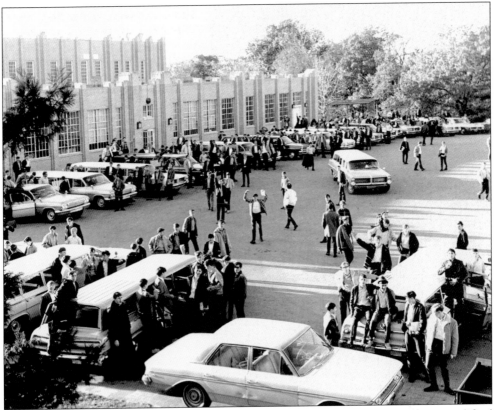

LIMBO WAGONS, LATE 1960s. To further reinforce the family home concept, modified station wagons designed to hold 14 students were ordered for all intermediate homes. The wagons, which debuted in January 1962, were often referred to as "limbo wagons" because of the swinging feeling that came from riding in the back. Once Catherine Hall opened in 1966 and students walked to school, the wagons were reassigned to the senior division.

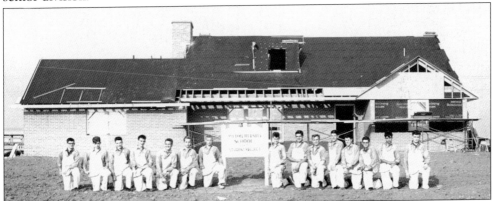

VOCATIONAL HOUSE PROJECT, 1964. For more than a 10-year period beginning in the late 1950s, the school's vocational department built a staff home each year. By the mid-1970s, all staff whose work was directly connected with the student programs on campus lived in homes built by the boys as part of their vocational training. This home was built for Charles Wolgemuth, an administrator with the Hershey Farm Company.

THE HOMESTEAD, 1966. The Anniversary Evaluation Committee also recommended construction of "a home for the superintendent and his family." In 1961, the Homestead, which had served as staff apartments since the death of Prudence Copenhaver in 1949, became home to Dr. John O. Hershey and his wife, Lucille. It became a cherished tradition for students visiting the Homestead to sit in Milton Hershey's chair.

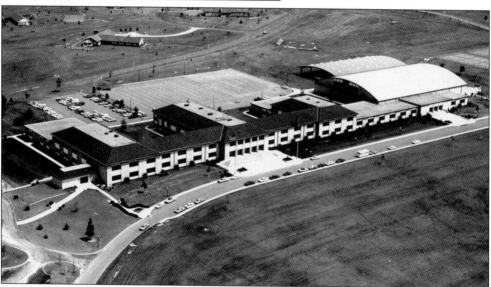

CATHERINE HALL, 1966. The new intermediate campus was located across the street from the Main and included a new middle school, known as Catherine Hall, and five clusters of homes designed to house up to 500 students within walking distance of the new school. Construction of Catherine Hall began in January 1965. The building opened in August 1966 for fifth through eighth grade students.

Catherine Hall Foyer, 1966. The building contained several unusual features, including a two-story spiral stairway, barbershop, ice-skating rink, and Olympic-sized swimming pool. As part of a new campus-wide building initiative, a new Catherine Hall was constructed in 1999. The original building was renovated and renamed Copenhaver Student Center.

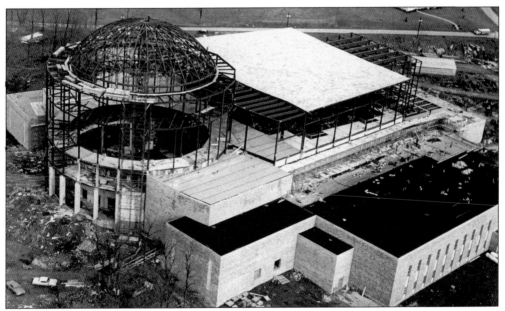

Founders Hall, 1969. The culmination of change and modernization envisioned by Dr. Hershey was reinforced by the Anniversary Evaluation Committee, which recommended construction of "an administration building in an appropriate location." The husband and wife architectural team of Clifford and Melissa Coleman spent seven years designing the building before breaking ground in August 1967. The 16,000 tons of native limestone used in construction were quarried on site.

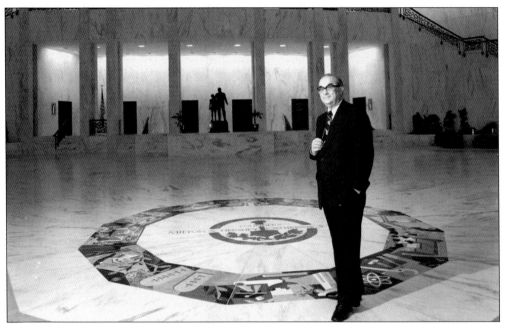

FOUNDERS HALL ROTUNDA, 1970. The most notable feature of Founders Hall is its rotunda. Constructed of nearly 1,550 tons of marble, it measures 74 feet from floor to interior ceiling. A mosaic in the center contains a time capsule that was sealed at the dedication on Milton Hershey's birthday, September 13, 1970. The statue of *Milton Hershey and the Boy* is behind Dr. John O. Hershey at the rear of the rotunda.

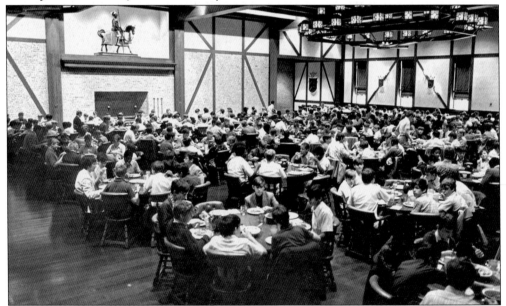

CAMELOT ROOM, 1970. Located in Founders Hall, the Camelot Room served as the main dining room for intermediate students and administrative staff. The medieval decor, from the knight over the fireplace to the brick-and-timber-framed walls, and family style seating were meant to reinforce the teaching of social graces and proper etiquette by harkening back to an age of chivalry. The decor was replaced in 1993.

DR. HERSHEY GREETING NEW STUDENTS, 1968. In May 1968, the admissions policy of the school was modified to admit non-white boys, and the first six students enrolled in August. In December 1970, the deed of trust was restated to admit boys between the ages of 4 and 16 years of age and without regard to race or color.

ELEMENTARY CLASSROOM, 1970. Of the first six non-white students enrolled in 1968, one was in seventh grade, three in eighth grade, one in ninth grade, and one in tenth grade. They were quickly joined by students in the younger grades. The first two non-white graduates were Marshall L. Nixon and Carl S. Wilson, who graduated in 1971. Wilson was one of the original six students enrolled in 1968.

FIRST GIRLS, 1977. The first eight girls were enrolled in the school on March 14, 1977. All eight were enrolled in the Junior Division (two in kindergarten, one in first grade, three in fourth grade, and two in fifth grade) and had brothers enrolled in the school. Girls were enrolled in the intermediate division in the summer of 1977 and the senior division in the summer of 1978.

Some Changes to Make Our School More Personal

In Intermediate Division girls and boys mix in classes for the first time.

A rose between two thorns.

Young ladies take part in a lesson.

An attractive Junior Division student.

"It's about time" we added some sugar to the campus.

Senior Division boys look forward to some of same next year.

And so, the ACROPOLIS welcomes young ladies.

The Brown and Gold band gets new and different look.

100L

With the admittance of young ladies to the student body, Milton Hershey School has taken yet another step to foster Mr. Hershey's dream of a benevolent institution where young people in need are presented the opportunity to receive a quality education. This major transition in policy has taken place with a maximum amount of efficiency allowing girls to enter the student body with a minimum degree of difficulty and few problems.

ACROPOLIS **YEARBOOK, 1978.** The decision to admit girls meant changes to the long-standing all-male history and traditions of the school. In the alma mater, the lyric "thy loyal sons are we" became "loyal and true are we." In a subsequent line reading "We're men of Milton Hershey and vow to that great name," the word "men" was simply changed to "proud."

Five

NEW DIRECTIONS
1981–2002

The retirement of Dr. John O. Hershey and the election of John McClellan "Mac" Aichele '39 as president in January 1981 signaled a new direction for the school. For the first time in its history, an alumnus now guided the school. As a student, faculty member, and administrator, Aichele knew the school from the inside out. His long and distinguished tenure with the school provided him with the necessary experience to immediately confront the challenges facing the school and at the same time confirmed the spirit of change embraced by the administration and Milton Hershey School Board of Managers throughout the 1960s and 1970s.

Aichele had enrolled in the school in 1935 and graduated in 1939. He returned to the school in 1944 to teach classes in business. He was named Alumnus of the Year in 1974 and by 1979 had become executive vice president. Aichele's administration was marked by a deep interest in campus and student life and bracketed by two key milestone events. During his first year as president, the school graduated its first female students. During the final year of his presidency, the school marked the 75th anniversary of its founding.

The academic year 1984–1985 marked the 75th anniversary of the signing of the deed of trust. In January 1985, William Fisher '50—who, like Aichele, had served the school for many years as both a teacher and administrator—was elected third president of the school. Fisher was enrolled in the school in 1944 and graduated in 1950. He returned to the school in 1956 to teach classes in English and German. By 1983, he had become vice president of education and in 1985 was named Alumnus of the Year. Fisher was an able administrator who believed in the abilities of his staff and wanted to provide opportunities for them to maximize their potential, so they in turn could do the same for their students.

During Fisher's tenure as president, the school underwent an intensive period of self-study intended to develop a long-range plan for the future. In February 1990, the school released a report containing seven directional goals and strategies, which came to be known as the "21st Century Initiative." The report contained a lot of new and far-reaching proposals intended to provide a road map for transforming the school into a world leader in private school education. In March, Fisher announced his intention to retire. Following Fisher's retirement, a tumultuous time ensued, as Milton Hershey

School struggled to define its mission. Wrenching debates and public battles played out over the future of the school, with many alumni protesting the direction the school was taking.

In August 1991, after a lengthy search, the Milton Hershey School Board of Managers selected Dr. Frances O'Connor as the fourth president of the school. O'Connor became the first female president of the school and the first to have no previous connection with Hershey. O'Connor's tenure lasted only nine months. She resigned in April 1992 and was immediately replaced by Rod Pera, chairman of the board of managers, who served as acting president while the board searched for a permanent replacement. The board believed they found that person in Dr. Arthur Levine of the Harvard Graduate School. Within a few short weeks of being chosen as the school's sixth president, Levine resigned, citing personal reasons. The board then selected Dr. William Lepley in September 1993, a school administrator from Iowa, to be the school's seventh president.

Dr. Lepley's administration was marked by intense controversy. His administration oversaw an expansive building campaign as his team sought to implement a new educational plan. As the school continued to focus on academic excellence, a vigorous debate over the types of students Milton Hershey School was founded to serve and the best way to prepare those students for the future occupied Lepley and the entire school community. Many alumni, dedicated men and women who were passionately committed to the school and viewed it as their family and home, vigorously protested decisions made by the Lepley administration, which they believed were moving the school away from the tenants of the deed of trust.

The selection of Johnny O'Brien '61, a past Alumnus of the Year, as the school's eighth president, marked a return to a program and philosophy focused on Milton and Catherine Hershey's deed of trust as a road map for the future—a program rooted in tradition and focused on success.

JOHN "MAC" AICHELE, 1944. A 1939 graduate of the school, John Aichele (far right) joined the staff in 1944 as a teacher in the business department. Aichele also coached football and basketball and served as director of athletics. He retired as president of the school in January 1985 and as chair of the Milton Hershey School Board of Managers in September 1986 after 42 years of service.

JOHN "MAC" AICHELE, 1981. During his long tenure with the school, Aichele served in a variety of administrative positions in the education and business affairs divisions and as executive vice-president before assuming the presidency in January 1981. His broad experience and positive disposition uniquely qualified him to guide the school following the retirement of Dr. John O. Hershey.

103

BOYS BASKETBALL CLASS A STATE CHAMPIONS, 1981. Because of John Aichele's interest in the welfare of students, he spent a great deal of time attending student functions and athletic events. His support paid off when the Spartan basketball team, coached by D. Michael Weller '66, won its first and only state basketball championship in March 1981.

COMMENCEMENT, 1981. The class of 1981 included 13 female graduates, the first girls to graduate from the school. Here in the entrance foyer of Senior Hall, a retired Dr. John O. Hershey congratulates Lynn Troischt (right) on her achievement. By virtue of the spelling of her last name, Christine Brennan Cook was the first to graduate. Today Cook is a kindergarten teacher at her alma mater.

THE 75TH ANNIVERSARY LOGO, 1984–1985. Charles Bofinger '43 designed a series of graphic materials to be used throughout the 75th anniversary school year. This particular logo was intended to emphasize how the school had grown and changed in both facilities and diversity since its inception in 1909, allowing more and more students to benefit from the philanthropy of Milton and Catherine Hershey.

HENRY HERSHEY FIELD DEDICATION, 1984. A highlight of the 75th anniversary celebration was the dedication of a new athletic facility during halftime of the homecoming football game on September 22. School president Aichele is pictured on the far left. At the podium is William Fisher, vice president of education, who would become the next president of the school in January 1985.

FOUR PRESIDENTS, NOVEMBER 1984. Milton Hershey had once said that it was one of his dreams to have one of "his boys" someday run his chocolate company. In the early 1980s that dream became a reality—and then some—when all four major corporate entities founded by Milton Hershey were headed by a "homeboy" or graduate of the school. These four men are, from left to right, John "Mac" Aichele '39, Milton Hershey School president; Kenneth Hatt '41, Hershey Entertainment and Resort Company president; Joseph Gumpher '35, Hershey Trust Company president; and seated, William Dearden '40, Hershey Foods Corporation chief executive officer.

WILLIAM FISHER, 1966. A 1950 graduate of the school, William Fisher joined the staff in 1956 as a German and English teacher. Six years later, he assumed his first administrative position as assistant director of secondary education and was promoted to director of education in 1964. He is pictured here at commencement with graduating senior speakers Timothy Day '66 (center) and Edward Russek '66 (right).

WILLIAM FISHER, 1985. In August 1983, Fisher was elected vice president of education in a move meant to help prepare a smooth line of succession upon the retirement of Aichele. Fisher led by example and was noted for his insistence on excellence from both students and staff. He served as president from January 1985 until August 1991.

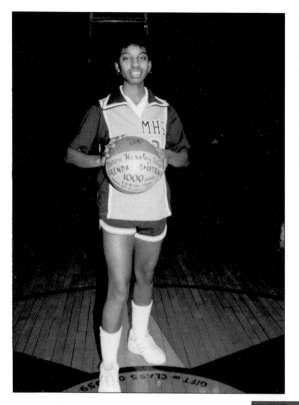

BRENDA ARMSTRONG, 1986. The Lady Spartans girls basketball team had reason to celebrate as Brenda Armstrong became the first female basketball player in school history to score over 1,000 career points. The only other girl to score over 1,000 points is Calia Carter '04. Carter also holds the girls basketball career scoring record.

STUDENT HOME DICKINSON, 1984. As part of a long-range planning process initiated by William Fisher, the school conducted an extensive marketing analysis. The final report, issued in October 1988, included recommendations for developing a unified print image and logo to aid in recruiting students and improving external relations. In March 1989, the school adopted the statue of *Milton Hershey and the Boy* as its official logo.

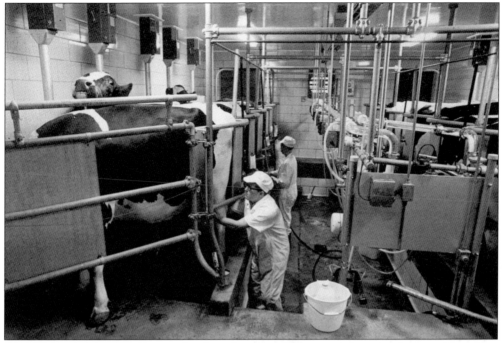

DAIRY 84, 1985. In February 1968, the school opened Dairy 84, a new freestanding show barn with two milking parlors for 100 cows, and by the end of the decade had completed renovation of all existing dairy barns. However, as the school began to take a closer look at the merits of the dairy chore program, staff began to realize that the interruptions of twice-a-day milking were having an adverse effect on classroom instruction and after-school activities. As a result, the school made the decision to eliminate the dairy chore program in August 1989; however the student home chore program remained intact as a way to teach responsibility and to help provide a sense of community within the student home.

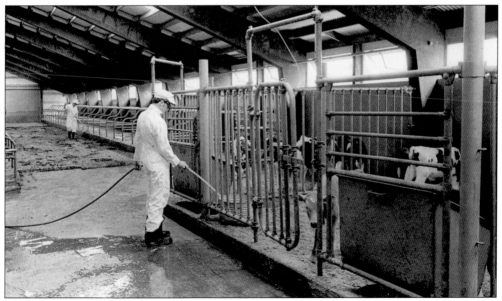

FRANCES O'CONNOR, 1991. Dr. Frances O'Connor came to the school in August 1991. She was an experienced educator with new ideas, and her selection as president reaffirmed the Milton Hershey School Board of Managers' desire to bring new ideas from the outside into the school.

STUDENT HOME PITCHER, 1995. Though her tenure at the school was short, Dr. O'Connor's interest in new technologies and new ways of doing things resulted in at least two noteworthy accomplishments. In September 1991, the school began placing computers in student homes for student use. That same month, the school also published the first issue of *Legacy*, a newsletter designed for alumni, parents, staff, and the public.

WILLIAM LEPLEY, 1993. During his presidency, Dr. William Lepley instituted a number of program changes and oversaw the completion of a number of building projects, including the construction of Town Center. The Town Center complex reflected the school's plan to create facilities to encourage children and adults to interact with each other and to promote "continual social, physical, cultural, and spiritual development."

VISIONARY AWARD, 1995. On May 26, 1995, nine elementary students received the first Milton S. Hershey Visionary Award, a new award given to students who best exemplify the character traits valued by Milton and Catherine Hershey. The annual award was started and funded by Maurice Sanko '45 and is managed by the School Alumni Relations and Programs Office.

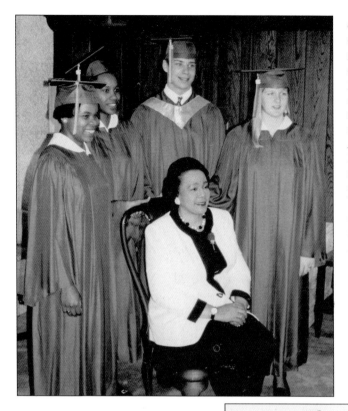

COMMENCEMENT, 1995. Coretta Scott King, civil rights activist and widow of slain civil rights leader Martin Luther King Jr., entitled her address to students, "You Can Make a Difference—Help Us Advance the Non-Violent Movement." In her remarks, she told students, "Every one of you can be great because all of you can be a servant of God and justice and peace and followers of Martin Luther King, Jr."

DEDICATION PROGRAM, FANNY B. HERSHEY MEMORIAL HALL, 1995. The dedication of a new elementary school on Founders Day 1995 marked the first step in the construction of a centralized academic campus. During the summer, the school also opened 20 new student homes. The use of new and existing homes meant that all elementary students could now walk to school.

A a Apple
B b Boy
C c Cat
F f Founders
G g Girl
M m Memorial Hall
S s Student Home
T t Tree Planting

A New Beginning

A celebration of Founders Day, Tree Planting, Dedication Ceremonies, and Open House
Wednesday, November 15, 1995 – 2:00 p.m.

HORTICULTURE CENTER, 1997. The Agricultural and Environmental Education (AEE) program began on November 15, 1993. In April 1997, the school broke ground on construction of a Horticulture Center for the AEE program to support year-round study of plants and crops in various environments.

ANIMAL CENTER, 2007. In keeping with the deed of trust, AEE also provides students with an opportunity to participate in an integrated agricultural program designed to foster improved agricultural and environmental literacy, facilitate development of life and career skills, and enhance student achievement in all academic areas through hands-on learning and first-hand experiences.

GIRLS TRACK CLASS AA STATE CHAMPIONS, 1995. The school has a strong tradition of excellence in both boys and girls athletics. Teams in all sports have captured numerous district and state championships. The girl's track team has been especially successful, capturing a total of 15 state championships as of 2006.

THE 90TH ANNIVERSARY LOGO, 1999–2000. In this logo designed by Malcolm Brown '99, the theme of "change" seemed especially appropriate as the school opened numerous new buildings in Town Center during the year. The opening of a new Senior Hall in August 2000 meant that the class of 2000 was the last class to graduate from the original building.

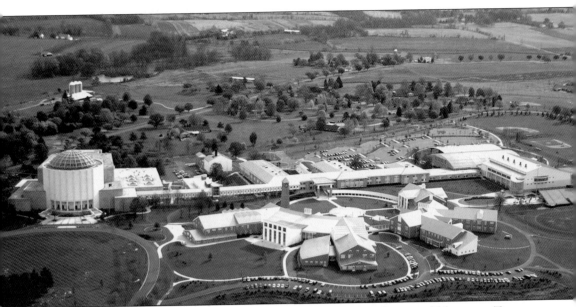

TOWN CENTER, 2001. In May 1998, ground was broken on what would become Town Center—a centralized campus anchored by Founders Hall on one side, a renovated and expanded Catherine Hall devoted to student support services in the center (renamed Copenhaver Student Center), and a new gymnasium and athletic complex known as Spartan Center on the opposite end. Directly across from these buildings a crescent-shaped trio of new academic support buildings was constructed. Seen here from left to right, they included a new high school with space for vocational-technical programs and shops, a new middle school, and a new library and learning resource center. The completed complex was dedicated in April 2001 and since 2003 has been known as Spartan Commons.

W. Allen Hammond Learning Resource Center, 1999. The Learning Resource Center (LRC) opened in August 1999 and was named in honor of the first principal of the former Junior-Senior High School. The LRC houses thousands of books and reference materials as well as the technological learning resources necessary to help teachers integrate technology into learning.

Catherine Hall Middle School, 1999. The second building to be named Catherine Hall opened in October 1999. Designed to accommodate students in sixth through eighth grades, the building contains traditional classrooms, labs, a team activity area for large group learning, and a forum area designed to hold up to 400 people.

116

SPARTAN CENTER, 2000. Spartan Center opened in January 2000. The building features a 1,800-seat performance gym that hosts athletic events for the high school teams. An indoor pool, strength-training room, aerobics fitness room, indoor track, three practice basketball/volleyball courts, a driving simulations studio, and classrooms for physical education and health classes are also located in this facility.

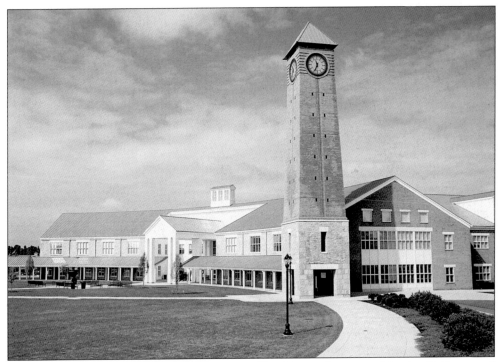

SENIOR HALL HIGH SCHOOL, 2000. The second building to be named Senior Hall opened in August 2000 for students in 9th through 12th grades. In addition to regular classrooms, the building includes space for 10 career/technical areas.

COPENHAVER STUDENT CENTER, 2000. The former Catherine Hall, Copenhaver Center opened in October 2000 and was named for both George and Prudence Copenhaver. Copenhaver Center includes dental and medical suites, student lounge and gathering areas, classrooms, performance spaces, and a television studio.

STACKS VISUAL ARTS CENTER, 2001. The Stacks Visual Arts Center located on the north side of Copenhaver Center opened in January 2001 and was named in honor of art teacher Clyde Stacks. The building contains a number of art studios on the first floor and an art gallery on the second floor.

Six

Rooted in Tradition, Focused on Success
2003 and Beyond

The selection of Johnny O'Brien '61 as interim president of Milton Hershey School in December 2002 signaled a rededication to a program and philosophy rooted in tradition and focused on success; a program focused on Milton and Catherine Hershey's deed of trust as a road map for the future. O'Brien's installation as the school's eighth president in September 2003 confirmed that rededication to mission and ensured that the school would continue to commit its financial and human resources to preparing the neediest of children to become productive citizens and leaders in their communities.

O'Brien had enrolled in the school in 1947 and graduated in 1961. As a student, O'Brien played junior-varsity football for future school president John "Mac" Aichele '39 and was taught German by teacher and future school president William Fisher '50. After graduation, O'Brien attended Princeton University where he received a degree in psychology and Johns Hopkins University where he received his Master of Arts degree in education. A career in research, teaching, and leadership in organizational effectiveness and experiential learning technology led him to found Renaissance Leadership, a management consulting firm specializing in facilitating organizational change and enhancing executive performance through leadership and team development. Throughout the years, O'Brien maintained close ties with the home and school he cherished and in 1990 was named Alumnus of the Year. During the 1990s, he worked with the Lepley administration, the School Alumni Association, and the Milton Hershey School Board of Managers to help facilitate dialogue and an exchange of ideas.

As president, O'Brien immediately set about to make a difference in the life of the school and its students. With input from the entire school community, he issued a "Transitional Action Plan" detailing priorities for the school—namely simplify, stabilize, and serve—and paving the way for new ideas and growth. New student-centered programs like Transition Services to support high school students and young alumni; Transitional Living residences for seniors to help them plan for life after graduation; Year Round

Experience programming to provide a consistent learning experience throughout the year in a safe and nurturing environment; and Springboard Academy, designed to help students transition to the school experience resulted in positive changes and successes. O'Brien also established the Spartan Peace Prize in memory of his brother Frankie. It is an annual award given to the high school student who best exemplifies the character of a peacemaker, one who stands up for the rights of others, especially for the underdog.

Together O'Brien and the Milton Hershey School Board of Managers reinforced the concept of Milton Hershey School as both school and home by constructing a number of new facilities, including a Community Recreation Center, a place for the entire school community to come together, have fun, and get to know one another during the summer months. Under O'Brien, the child-saving mission continued to grow as enrollment blossomed from approximately 1,300 in 2002 to 1,800 in 2008. Enrollment is expected to reach 2,000 in 2012.

In November 2008, O'Brien announced his retirement from Milton Hershey School, effective at the close of the 2008–2009 school year. O'Brien's success in restoring the school and home to its original mission as outlined in the deed of trust, growing enrollment to serve as many children as possible, and creating a program focused on student and young graduate success convinced him that a firm foundation existed to support the next 100 years of serving and saving the lives of children. His retirement also assured that new leadership would have an opportunity to immediately place its mark on the school by hosting the school centennial celebration during the 2009–2010 school year.

As the board approved mission statement from January 2004 states "The mission of Milton Hershey School remains true to the ideals upon which it was founded more than ninety years ago—In keeping with Milton and Catherine's Hershey's Deed of Trust, Milton Hershey School nurtures and educates children in social and financial need to lead fulfilling and productive lives."

As the school prepares to enter its second century of service to youth in need, the vision of Milton and Catherine remains alive and well.

JOHNNY O'BRIEN, 2003. Johnny O'Brien's dedication to the vision of Milton and Catherine Hershey has resulted in a renewed spirit of commitment to student success and school traditions. During his tenure, O'Brien oversaw the renovation of historic student homes into modern student residences, the Homestead into a unique educational and commemorative space, Old Senior Hall into a new home for the middle school, and Kinderhaus into a School Heritage Center.

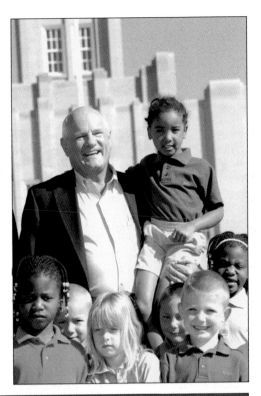

TRANSITIONAL LIVING, 2006. The school's first transitional living homes for seniors opened in January 2006. The initial group consisted of 20 males living in Caaba and 20 girls living in Emerson. In 2007, all seniors lived in transitional living homes. Transitional living provides all seniors with a learning laboratory in which they can practice and apply skills of self-sufficiency to prepare them to lead fulfilling and productive lives.

121

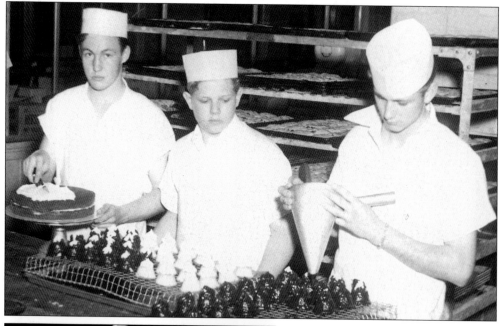

THEN AND NOW, VOCATIONAL TRAINING, 1940S AND 2006. In 1939, the school began the baking and candy making vocational program where students were taught a particular job skill. Today culinary arts and other career/technical paths offer students a wider variety of training in a particular field—training that will enable students to enter a meaningful career field or have the academic basis to continue schooling after graduation. Vocational and career/technical training can trace their evolution all the way back to Milton Hershey's own experiences as an apprentice candy maker in his youth. Although times have changed, the lessons and personal habits learned by Hershey as an apprentice or by students participating in vocational and career/technical education have remained very much the same—to provide a real world experience and to give students a greater competitive edge in today's workforce.

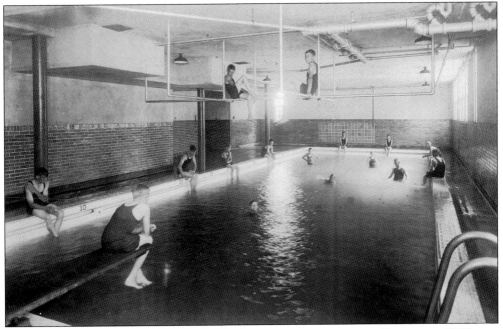

THEN AND NOW, MEMORIAL HALL AND THE COMMUNITY RECREATION CENTER, *c.* 1955 AND 2006. Milton Hershey intentionally chose a rural location for the site of his school. He believed that good food and country living helped build strong bodies and healthy minds. In this environment, swimming proved to be a popular pastime with the boys. When Memorial Hall opened in 1927, it was the first elementary school in the nation to have an indoor swimming pool. When the Junior-Senior High School opened in 1934, it also contained a large pool, and when Catherine Hall opened in 1966, it contained an Olympic-sized swimming and diving pool. In May 2006, the school opened an on-campus Community Recreation Center to provide students with an outdoor swimming alternative in a positive, fun, and safe environment.

PURCELL FRIENDSHIP HALL, 2007. Dedicated during homecoming in September 2006, the Friendship Hall is part of the William E. Dearden Alumni Campus—a place where alumni, students, and staff can gather together as a community to honor the legacy of Milton and Catherine Hershey. Located on the site of former student farm home Glendale, the renovated barn is named in honor of Richard (Dick) Purcell '61.

SPARTAN PEACE PRIZE, 2007. The annual Spartan Peace Prize, first awarded in 2004, is bestowed upon a student who has done the most to promote respect by students for other students and staff. In particular, the award recognizes a student who has played a significant role in efforts to eliminate bullying on the school campus.

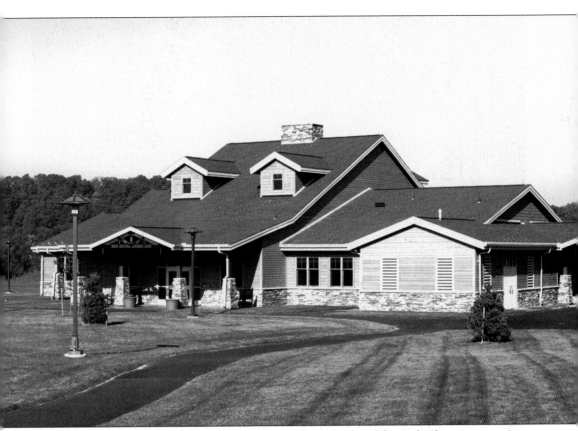

SPRINGBOARD ACADEMY, 2007. In August 2007, the school launched an innovative program designed to help middle school students transition into the residential learning environment. Called Springboard Academy, the program is housed on a mini-campus focused on providing experiential education to meet the unique needs of each student. The core planning and operating philosophies of Springboard Academy are innovation, possibilities thinking, commitment to student success, and experiential education. Springboard Academy also includes special programs to keep parents and sponsors connected to their child and to the school. The first 75 students enrolled in September 2007.

CATHERINE HALL MIDDLE SCHOOL, 2007. The third building to be named after Catherine Hershey opened to middle school students in August 2007. After undergoing an extensive remodeling, the former Junior-Senior High School building is now a state-of-the-art learning facility for grades five through eight.

BOARD OF MANAGERS, 2008. With the full support of the board, the 2009–2010 academic year will serve as the backdrop for the school centennial celebration. The celebration is centered on the theme of "living the vision" and will take note of the past contributions of the school in improving the lives of children while recognizing the limitless potential of the future—a future, rooted in tradition, focused on success.